water olor

in motion

how to create powerful
paintings *step by step*

birgit o'connor

NORTH LIGHT BOOKS
CINCINNATI, OHIO
www.artistsnetwork.com

Watercolor in Motion. Copyright © 2008 by Birgit O'Connor. Manufactured in China. All rights reserved. No part of this book may be reproduced in any form or by any electronic or mechanical means including information storage and retrieval systems without permission in writing from the publisher, except by a reviewer who may quote brief passages in a review. Published by North Light Books, an imprint of F+W Media, Inc., 10151 Carver Road, Suite 200, Blue Ash, OH 45242. (800) 289-0963. First Paperback Edition 2014.

Other fine North Light Books are available from your local bookstore, art supply store or online supplier. Visit our website at fwmedia.com.

18 17 16 15 14 5 4 3 2 1

DISTRIBUTED IN CANADA BY FRASER DIRECT
100 Armstrong Avenue
Georgetown, ON, Canada L7G 5S4
Tel: (905) 877-4411

DISTRIBUTED IN THE U.K. AND EUROPE BY DAVID & CHARLES
Brunel House, Newton Abbot, Devon, TQ12 4PU, England
Tel: (+44) 1626 323200, Fax: (+44) 1626 323319
Email: postmaster@davidandcharles.co.uk

DISTRIBUTED IN AUSTRALIA BY CAPRICORN LINK
P.O. Box 704, S. Windsor NSW, 2756 Australia
Tel: (02) 4560 1600; Fax: (02) 4577 5288
Email: books@capricornlink.com.au

Library of Congress has cataloged hardcover edition as follows:
O'Connor, Birgit.
 Watercolor in motion / Birgit O'Connor.
 p. cm.
 Includes index.
 ISBN-13: 978-1-58180-883-4 (hardcover : alk. paper)
 1. Watercolor painting--Technique. I. Title.
 ND2420.O27 2008
 751.42'2--dc22 2007027232
 ISBN: 978-1-4403-3717-8 (pbk. : alk paper)

Edited by Amy Jeynes and Mona Michael
Designed by Wendy Dunning
Production coordinated by Matt Wagner

METRIC CONVERSION CHART

To convert	to	multiply by
Inches	Centimeters	2.54
Centimeters	Inches	0.4
Feet	Centimeters	30.5
Centimeters	Feet	0.03
Yards	Meters	0.9
Meters	Yards	1.1

ABOUT THE AUTHOR

Birgit O'Connor is a self-taught painter who has been working
strictly in watercolor since 1988. She has been teaching watercolor
instruction since 2001. She has written for several magazines,
including *Watercolor Magic*, *The Artist's Magazine* and *Artist's Sketch-
book*, and she has produced thirteen watercolor instruction videos.
Her award-winning work has been exhibited in dozens of one-
woman shows and group shows and can be found in private
and corporate collections around the globe as well as in four
galleries. She resides in northern California. Visit her website,
www.birgitoconnor.com.

contents

VIDEO

DANCING TULIPS
30" × 40" (76CM × 102CM)
WATERCOLOR ON 300-LB. (640GSM) COLD PRESS

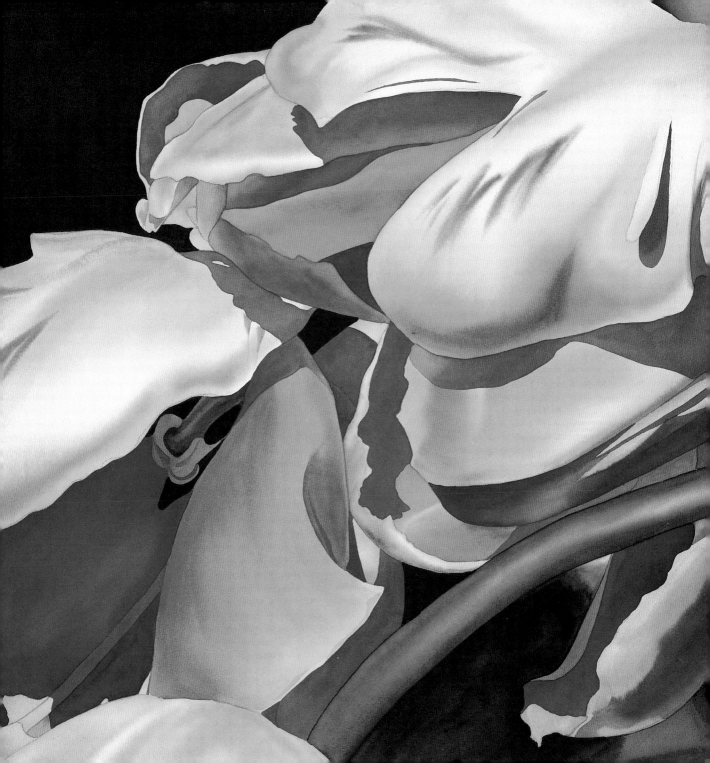

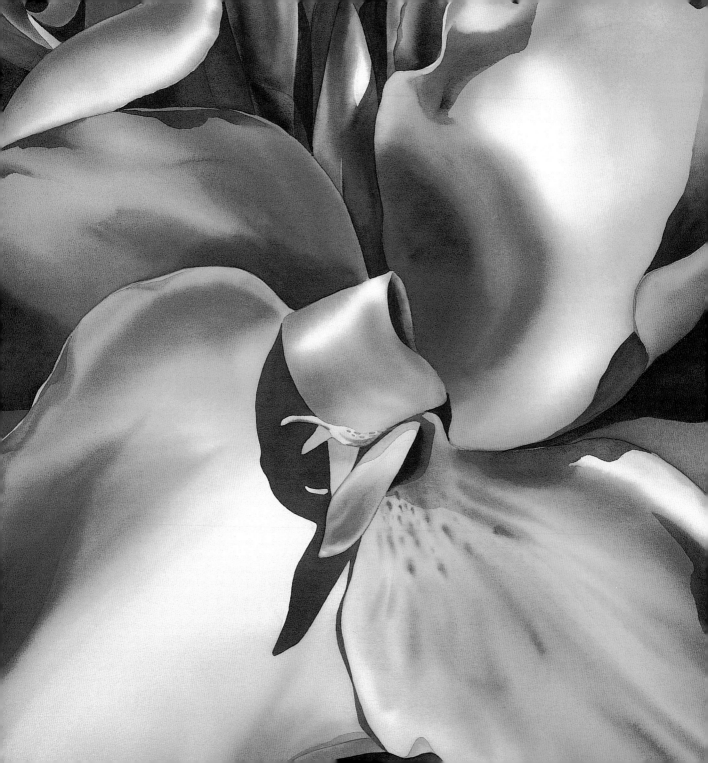

introduction

Watercolor has always been perceived as a very unforgiving medium that offers very little control. This can cause a lot of frustration. But the effects and luminous washes possible with watercolor are unrivaled. In order to take advantage of the way watercolor works, there are some basic things you need to know.

FIND THE PROPER MATERIALS

Using brushes that are too small or a poor grade of paper are paths to frustration. In the pages that follow and in the DVD, you'll learn what to look for in materials to achieve the best results (along with my favorites).

THINK BACKWARD

Instead of beginning with the darks and then adding the lighter colors, begin with the lighter areas and then move toward the darker colors.

SIMPLIFY

As a self-taught artist with years of experience, I have found that it is most important to simplify. I have tried to convey this through my articles, books and DVDs. You'll get a feel for my techniques with these very simple step-by-step demonstrations.

USE ENOUGH WATER

Once you have an understanding of how to really use water and color to your advantage, the rest is up to you. The world is wide open.

Use water to your advantage
The use of water on each petal allows the color to flow out from the edges back into the center, creating a natural illusion of highlights.

CANNA SANTA ROSA
40" × 30" (102CM × 76CM)
WATERCOLOR ON 300-LB. (640GSM) COLD PRESS

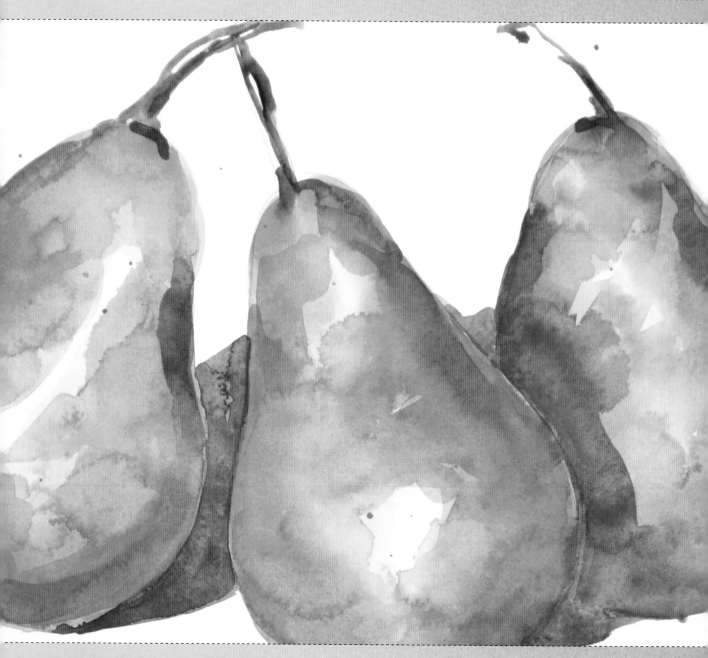

materials

Many beginning watercolor artists try to get by with inexpensive paint and whatever brushes or paper they happen to have on hand. However, if your tools and materials aren't well suited for watercolor techniques, you'll be disappointed with the results.

This chapter explains what kinds of paper, paint and brushes work best, and why. Having a better understanding of the differences among products will make it easier to choose, and ultimately it will make all the difference in the world for the success of your watercolor paintings.

Painting loose on hot-pressed paper
Backwashing of color on hot-pressed paper is a problem if you want to work tightly; on the other hand, if you want to paint loose, you can have a lot of fun using backwashes and flowering effects to your advantage.

FROM THE GARDEN
22" × 30" (56CM X 76CM)
WATERCOLOR ON 140-LB. (300GSM)
HOT PRESS

how to choose watercolor paint

Using quality paints will give you the transparency, luminous colors and coverage you need for powerful watercolor paintings.

TUBES VS. PANS

Tube watercolors are moist and creamy, and they mix easily with water on your palette or paper to produce the desired consistency.

Pans are small dried blocks of color that need to be rewetted before you can use them. It can be difficult to mix pan colors to a uniform consistency for a large-area wash.

Pans are convenient for traveling, and they can be used for a detailed painting that requires small brushes and less water. We'll concentrate on creating bold paintings using large brushes and plenty of water. Usually, pans are too small for large brushes and are difficult to use in expansive washes; recently, though, larger pans have become available, making them a bit easier to use. It's a personal choice. Feel free to try them both.

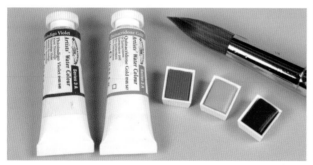

Why I prefer tubes
Tube colors have a consistent creamy texture, and you can squeeze out as much as you need at any time. Pan colors are harder to blend with water, and the small size of the pans makes it difficult to use large brushes without contaminating other colors.

PROFESSIONAL GRADE VS. STUDENT GRADE

For the best results, use professional-grade, transparent watercolors. Student-grade pigments have more filler and less color, and the student grade of a color is noticeably different from its professional-grade brandmate. Professional-grade paints cost more, but, since they contain more pigment and less binder, you will save time and money in the long run—especially if you buy them in large tube sizes.

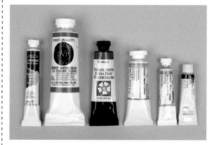

Save money with large tubes
Here are some examples of the range of tube sizes available. Professional-grade paints in large tubes will give you better results and are the best buy in the long run.

WHICH BRAND?

My favorite professional watercolor brands are Winsor & Newton, Schmincke and Daniel Smith; try these and other brands to discover your favorites. Many brands are excellent; the most important thing is to choose professional-grade paint for the best pigment load color and permanency.

And remember, two paints from different manufacturers may have the same color name but look slightly different. Some Indigos are bluer, others greener. Some Quinacridone Golds are a light yellow-gold, while others are brownish or even greenish gold. This is why it's best to test your colors first and see which brands and hues you like best.

watercolor paper

Most paper is made of cellulose from cotton fiber or wood pulp. Wood-pulp paper (such as newsprint or construction paper) is less durable, more acidic and not archival. This is known as "student grade." Over time, these can disintegrate and should be used mainly for craft or student projects.

Cotton (most often called 100 percent rag paper) is the highest quality and most archival grade paper. It is acid-free and is the most durable, allowing for a lot of lifting and reworking of the surface without showing much wear and tear.

HOW PAPER IS MADE

Fibers are beaten into a liquid pulp, which is poured into a mold with a textured screen on the bottom that allows excess water to run out. The paper is dried in this mold, so the texture of the screen is impressed on one side of the paper. This is called the *wire side* of the paper. The top side of the sheet, the one not touching the screen, is usually smoother. This is called the *felt side*. The way the sheet is treated after molding determines its final surface texture.

PAPER FINISH	HOW IT'S MADE	SURFACE	WORKING CHARACTERISTICS
Hot press	Sheet dries in the mold, then is run through heated rollers to iron out the texture.	Smooth, hard, not very absorbent.	Controlled washes are difficult to achieve. Ideal where more dry-brush techniques are used (as in botanical illustrations). Works well for loose paintings where backruns and blossoming can be used to your advantage.
Cold press	Sheet is removed from mold when not quite dry, then pressed without heat.	Semismooth, absorbent.	Absorbs water and color well and is easily workable. It is the most commonly used surface for watercolor.
Rough	Sheet is allowed to air-dry in the mold without any smoothing or pressing.	Very rough, absorbent.	Color skips across the rough surface and settles in the hollows, creating interesting effects. Wonderful for bold work or subjects for which texture is an advantage, such as fences, wood, barns or rocks. Not recommended for finely detailed paintings.

SIZING

Look for papers with both internal and external sizing. The external sizing creates a less absorbent and harder surface, allowing the color to remain on top, leaving the impression of more color saturation. Paper with only internal sizing tends to be soft and more absorbent, making it difficult to achieve deep color saturation because color soaks into the paper.

THE DECKLE EDGE

After paper pulp is poured into a mold, a wooden frame rests on top that defines the edges of the sheet. This gives the edge of a sheet its feathered appearance, called the *deckle edge*.

THE WATERMARK

If you hold a sheet of watercolor paper at an angle, you'll see the manufacturer's name or symbol impressed in the paper. This is the *watermark*. The side on which it reads legibly is the felt side, the smoother and more consistent side (but both sides can be used).

The watermark
The side on which the watermark reads correctly is usually considered the "right" side of the paper.

HANDS OFF

Handle your paper as little as possible and make sure you don't have oil or lotion on your hands; these can act like a resist, repelling color from areas and possibly leaving uneven washes.

BY THE PAD, SHEET OR ROLL?

Pads consist of mouldmade 100 percent cotton paper with sealed adhesive edges. They come in a variety of sizes, don't need to be stretched and are great for traveling. To separate the paper from the block, insert a small palette knife at the small entry point along the side and follow the seam.

Standard full sheets of watercolor paper measure 22" × 30" (56cm × 76cm). A *single elephant* sheet measures 25¾" × 40" (65cm × 102cm), a *double elephant* 30" × 40" (76cm × 102cm) and a *triple elephant* 40" × 60" (102cm × 152cm). Larger sizes can be hard to find; you can ask your local art store to special order them, or try mail-order companies.

Rolls of watercolor paper measuring 44½" × 10 yards (113cm × 9m) are very economical, but a roll can be difficult to use. To remove the memory of the curl, cut the paper to the desired size, soak it in a tub, then hang it on a line using clothespins, or mount to a board using staples, tape or bulldog clips.

TEARING PAPER TO SIZE

Instead of cutting paper to size, tear it. Tearing creates an attractive edge similar to a deckle edge that you can paint out to and even leave visible when framing.

Fold it back and forth repeatedly to weaken the seam. Then, fold side up, gently start a small tear along the top end, then place the paper on the edge of a table or, using a straight-edge, apply equal pressure to one side while tearing in one upward motion on the other side. (Note: Some papers are harder to tear due to surface textures. In these cases, wet the seam first with clean water to soften.)

How to tear paper
Fold your paper back and forth to weaken the seam, then tear it along either a straightedge or the edge of a table.

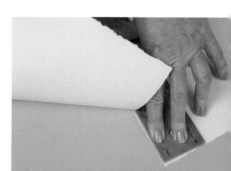

brush size and shape

Brushes created for use with acrylics and oils usually are too soft or hard, often too small, and don't hold enough water. They simply will not work for watercolor techniques such as creating large, smooth, blended washes. Good watercolor brushes are well worth the investment (but don't always have to be the most expensive ones). There is no need to throw your other brushes away, either. You may find other uses for them such as scrubbing the surface and creating texture.

BRUSH SIZES
Most watercolorists use either 1-inch (25mm) or ½-inch (12mm) flats (which are fine for more angular painting) or nos. 6, 8 and 10 rounds. These smaller brushes are fine for smaller paintings, and they work well for details and for work with a high degree of realism.

However, if you decide to do larger paintings, brushes in this size range can leave too many brushstrokes and make your paintings look overworked and dry. So, as you increase the size of your paintings, also increase the size of your brushes. Unless you want tight work, consider using nos. 8, 14, 20 and 30 rounds. You will understand why as we go along. Many art stores do not carry larger brush sizes; however, most will order them for you.

Try working big
Below: On the left are nos. 3, 6 and 8 rounds, the sizes most watercolorists use. Compare those to the ones on the right, which show the range I prefer: nos. 12, 16,14, 20 and 30.

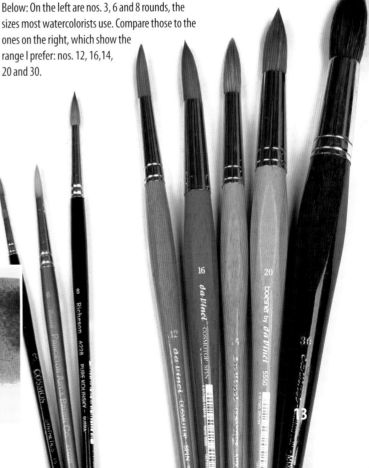

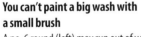

You can't paint a big wash with a small brush
A no. 6 round (left) may run out of water quickly, making it difficult to wash color over a large area. Before you can finish the area, portions are already dry, causing visible brushstrokes and an overworked appearance.

Larger areas require larger brushes
A no. 20 round (right) covers a large area in only a few strokes. The resulting coverage and color are much smoother than if you try to cover the same area with a small brush.

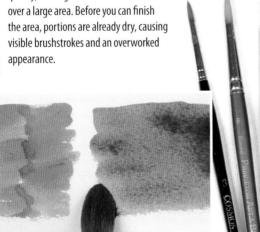

brush fibers

Brushes can be made with natural hairs, synthetic fibers or a blend of the two. Each of these brush types has its strengths, and I use them all (see page 16).

NATURAL FIBERS

Brushes made with natural fibers hold more water than synthetics. They are soft, allowing you to easily layer color upon color without lifting the previous layer. Some lesser quality natural-hair brushes may be too soft, lacking in elasticity or spring, making it difficult to control the stroke. When natural-hair brushes are wet, their tips stay bent once they touch the paper. I look for brushes that hold just the right amount of water, with some elasticity and spring for control and a nice point for tighter areas. Many different types of natural hair are available, such as camel, skunk, ox, goat, squirrel, red sable and kolinsky sable. You can also find brushes with combinations of natural hair. I like the Da Vinci Cosmotop Mix B that combines kolinsky red sable, Russian blue squirrel and ox hair.

SYNTHETICS

Synthetic brushes usually cost less than natural-hair brushes. And many high-quality synthetic brushes are available today. Synthetic brushes spring back to form quickly, but they don't hold as much water as natural-hair brushes. Some lower quality synthetics may be too stiff, too, causing previously painted color to lift out when you try to layer. Higher quality synthetics are softer; some of them are almost comparable to sable/synthetic blends. Since synthetics hold less water, color stays together better when a stroke is applied to a wet surface, making synthetics ideal for detail work.

SABLE/SYNTHETIC BLENDS

Sable/synthetic blends offer a nice blend of the best attributes of natural hair and high-quality synthetics. Blended brushes hold ample amounts of water and are soft enough for layering without lifting, yet they still have the spring and control of a synthetic.

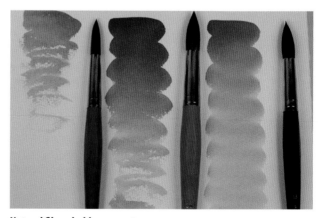

Natural fibers hold more water
The synthetic brush (left) holds the least water and runs out of color first. The sable/synthetic blend (middle) holds more water than the synthetic but not as much as a natural brush. The natural-hair brush (right) holds the most water, making color application almost effortless.

Natural hair vs. blended fibers
The left brushstroke was a natural-hair brush that skipped across the tooth of the paper because the hair fibers are softer with less spring. The right brushstroke was a natural/synthetic blend brush. The addition of synthetic fibers to the natural ones gives the stroke a cleaner edge and a bolder, more deliberate look.

14

brush handling and care

A few good brushes can last a lifetime if you take care of them.

HOLDING A BRUSH

Don't hold your brush as if it were a pencil. Hold it a little higher up the handle so it rests loosely in your hand. Find the balancing point at which the brush is comfortable in your hand but you can still control it. Painting this way will give your art a more natural appearance. The only time you need to hold a brush closer to the tip is when you are working on tighter details.

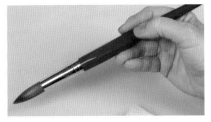

How to hold a brush
Hold the brush at its balancing point so it feels loose and natural in your hand but you can still control it.

Save the pencil grip for details
Holding your brush like a pencil is best reserved for detail work with small brushes.

BRUSH CARE

The most important rule is: Never place your brush tip down in a water container. This can permanently deform the brush.

Instead, have an old terry cloth towel next to the water container. Clean your brush, then lay it on the towel. A few other rules:

- Don't submerge the entire tip in paint. Keep the color out to the point and not by the ferrule.
- Use watercolor brushes only for watercolor.
- Use only old, inexpensive brushes for masking fluid.
- Dip your brush in water before you begin to prepare the tip to apply color.

What not to do
Don't leave a brush tip down in water. The bristles may become permanently deformed.

USE A BIG WATER BUCKET

Use a large water container, and you will have to change the water far less often than if you use a small one. Your colors will stay cleaner and brighter, too. My 1-gallon (3.8-liter) bucket came from a feed store. Even a plastic milk jug with the top half cut off will work.

recommended brushes

Shown here are the types of brushes you'll need for this book. Try many different brands and you'll find your own favorites. I've explained the characteristics of my favorite brushes so you'll know what brush characteristics will work well for the techniques you're about to learn.

▲ Synthetic wash brush (optional)
My no. 60 Cosmotop wash mottler holds a surprising amount of water for such a convenient size.

Nos. 8 and 20 synthetic rounds ▶
Pictured are Da Vinci Cosmotop Spin synthetic rounds. High-quality synthetic rounds are perfect for details or adding bends and folds.

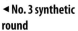

◄ No. 3 synthetic round
The Nova no. 3 is an inexpensive synthetic, considered a student-grade brush. Its stiff point works well for lifting loose brush hairs from a wash or for adding delicate details.

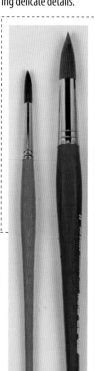

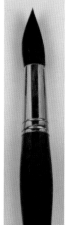

◄ Large, natural-hair round
The Da Vinci Cosmotop Mix B no. 30 is a combination of several natural fibers. It has a nice tip for detailed areas and nice spring to cover the paper surface without skipping. Another good choice is a no. 10 Isabey, which is equivalent in size to the Cosmotop 30 but is a bit softer and more difficult to control.

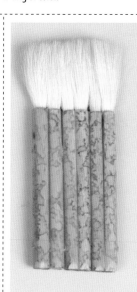

◄ Nos. 20, 14 and 8 sable/ synthetic blend rounds
The Da Vinci Cosmotop Mix F pictured here is a nice combination of natural hair and quality synthetic fibers. The natural hair holds a large amount of water, while the synthetic fibers add spring. This is an all-around dependable brush, soft enough for layering without unwanted lifting of color.

▲ 3-inch (8cm) bamboo hake
This inexpensive brush holds lots of water, allowing great flow of color. Its hairs tend to fall out easily, which can create problems in large washes.

materials checklist

You now have an understanding of why I recommend the materials and tools I do. Being an educated shopper will help you enjoy greater success with your art.

Use this page as a quick reference for the tools and materials you'll need for this book. And feel free to experiment.

WATERCOLOR PAPER
140-lb. (300gsm) or 300-lb. (640gsm) cold press • 300-lb. (640gsm) rough press

BRUSHES
½-inch (12mm) flat • ½-inch (12mm) or ¼-inch (6mm) nylon flat • No. 30 natural-hair round • Nos. 8, 12, 14 and 20 sable/synthetic blend rounds • Nos. 3, 8 and 20 synthetic rounds • soft wash brush, such as a 2½-inch (6cm) bamboo hake or a 1-inch (25mm) to 3-inch (8cm) natural-hair mop

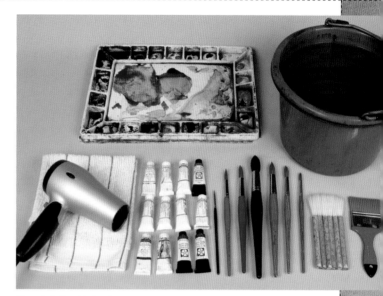

Materials for this book

TRANSPARENT WATERCOLORS (TUBES, NOT PANS)
Alizarin Carmine • Alizarin Crimson • Burnt Sienna • Burnt Umber • *Cadmium or Hansa Yellow • Carbazole Violet • Cobalt Blue • Emerald Green • French Ultramarine • Hansa Yellow Medium • Indanthrene Blue • Indian Yellow • Indigo • Naples Yellow • New Gamboge • Permanent Alizarin Crimson • Permanent Carmine • Permanent Sap Green • Phthalo Blue • Phthalo Green • Purple Madder • Quinacridone Gold • Quinacridone Magenta • Sap Green or Viridian • Yellow Ochre • Winsor Blue • Winsor Red

OTHER
compass or 4-inch (10cm) circle template • fine-point permanent marker • hair dryer • incredible nib or bamboo drawing pen • masking fluid • No. 2 graphite pencil or grade B art pencil • notebook (to keep track of pigments or notes while painting) • old small disposable brush • old terry cloth towel • one or two plastic water containers, ½ to 1 gallon (2 to 4 liters) each • paper towels • plastic palette with cover • rubber eraser • ruler • waterproof ink pen

*Both are Daniel Smith colors. If you have trouble finding either of these yellows, try Indian Yellow.

color and color mixing

Color affects how we feel. It has the ability to lift, rejuvenate, diminish or destroy. For years, manufacturers have known that the right color on a product can increase its sales. In many cultures, color is used as an indicator of status or religion. Studies have shown that light and color can affect our physical and emotional well-being, even our appetites. Color in a painting can be a healing experience for both the artist and the viewer.

Many people go through their entire lives distinguishing color in only the most basic terms—red, blue, yellow, purple, green, orange. If that's you, prepare yourself for a new color experience! When you start mixing watercolors, the world of color opens up to you. You may find it difficult to drive down the road without being mesmerized by all the subtle variations of color you see.

Consistent color, broad petals

This unusual tulip composition features large, broad swaths of color. The challenge of working at this size is in keeping the color consistent and flowing and keeping one area from drying quicker than others.

THE PETAL
40" × 30" (102CM × 76CM)
WATERCOLOR ON 300-LB. (640GSM)
COLD PRESS

the power of color

Color, being a vibration of light waves, has the ability to provoke emotional healing and to sway thinking.

Try this experiment. Sit for a moment and ask yourself to identify an emotion; then think about which color represents that emotion to you. What color is happiness? Sadness? Anger? Love? Your first response will be the correct answer. There is no right or wrong answer because people are so different. For one person, happiness might be pink or orange; for another, it may be green.

When painting, instead of trying to be technically exact with color choices and mixtures, allow your intuition to guide you and use colors you're attracted to. This will allow more of your authentic creative voice to come through, which will give your paintings more feeling.

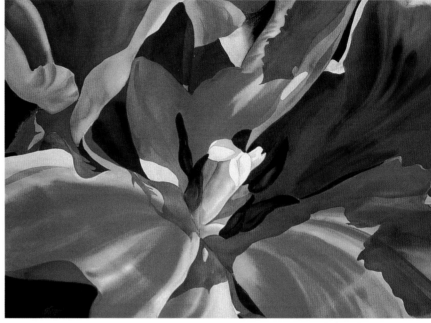

Unreserved and open
Painting using reds was always difficult for me. I didn't like them. They repelled me. However, with this composition I was able to work my way through the emotion of the reds and turn it into something that represented openness.

THE OPENING
40" × 60" (102CM × 152CM)
WATERCOLOR ON 1114-LB. (2340GSM) COLD PRESS

ALLOW MUSIC TO GUIDE YOU

To reach a deeper level of creative expression, listen to music while you paint. The combination of beat and color helps to distract your thinking mind. This lets you feel your emotions more. Your painting, in turn, will become a natural extension or expression of your feelings. If you usually paint in silence, add music; if you always listen to one kind of music, change it and see what happens.

color terms

Here are definitions for the color terms I use.

Hue | The basic color of an object (red, yellow and so on).

Local color | The true color of an object's surface, without any influence from atmospheric conditions or the color of the light.

Shade | The result of darkening a color with black or the color's complement.

Temperature | The warmth or coolness of a color. Reds and yellows are warm; blues and greens are cool. However, temperature is relative: Some reds are cooler than others, and some blues are warmer than others.

Tint | The result of lightening a color pigment (in watercolor, this is done by adding water).

Tone | A general term often used interchangeably with value.

Value | The lightness or darkness of a color.

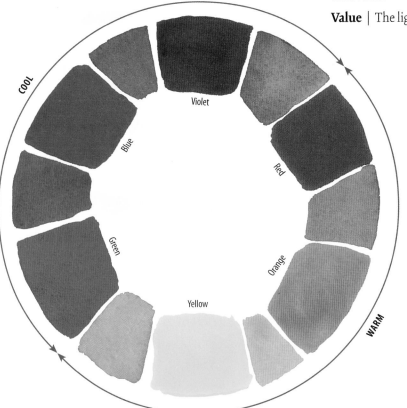

WHAT IS COLOR?

When all the wavelengths of light in the visible spectrum are present, the light looks white. So, if an object reflects all light wavelengths equally, it appears white. An object that absorbs certain wavelengths and reflects others is perceived as being the color of the reflected light waves.

The color wheel
Using *complements* (colors opposite one another on the color wheel) can make your paintings more vibrant.

paint properties

To learn the properties of the paints on your palette, consult the tube label or the manufacturer's brochure—or do your own tests.

STAINING

Staining colors adhere stubbornly to the paper surface. Colors that lift out easily are called *nonstaining* colors.

| Burnt Sienna | Winsor Green | French Ultramarine | Alizarin Crimson |

Staining test

To test your colors, create a 2" × 1" (5cm x 3cm) swatch of color and allow it to dry completely. Then wet one side of the color and blot with a paper towel or gently scrub it with a brush. You will be able to see which colors stain the most.

GRANULATION

Certain colors, such as French Ultramarine, Cobalt Blue, Cerulean Blue, Manganese Blue and Raw Umber, have large pigment particles that quickly settle out of the binder and into the paper surface. This property can create some very interesting textural effects. To reduce this effect, use a hair dryer to homogenize and stop the color from separating as it dries.

Grainy washes
French Ultramarine is a sedimentary color; its heavy pigment particles quickly settle into the paper texture, creating grainy textures in washes.

PERMANENCE

When choosing colors, always look for those with the manufacturer's highest lightfastness rating so your paintings will hold up over time. Colors with low lightfastness ratings are called *fugitive colors*; avoid these.

Try your own color permanency test: Place strokes of color on a piece of watercolor paper and block out one side of the strokes with a strip of mat board or aluminum tape (anything that doesn't allow light to pass through). Leave the sheet in the sun for about four months, then remove the tape and compare the two sides.

OPACITY/TRANSPARENCY

Transparent colors allow light to pass through. They are best for glazing; they allow the white of the paper surface to reflect light through the paint film, creating jewel-like color. Washes of transparent colors look very clean.

Opaque colors are dense and chalky and do not allow much light to pass through, so they are able to block out some previously applied colors. Remember that opaque colors, when overmixed, can quickly become muddy.

Water is the key to transparency. Even an opaque color becomes more transparent when you add more water.

Phthalo Blue

Hansa Yellow

Glazing with transparents

Transparent pigments glaze well with less bleeding.

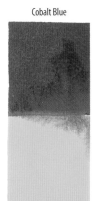

Cobalt Blue Cobalt Blue

Cadmium Yellow Cadmium Orange

Pigments that bleed

Cadmium pigments are not well suited for glazing; they tend to bleed into other colors even after the other color has dried.

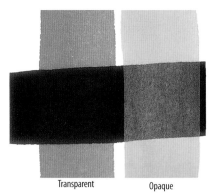

Transparent Opaque

Testing for transparency

Test the colors on your palette by painting them over a dried stripe of India ink. *Transparent pigments* will appear to disappear where they cross the ink. *Opaque pigments* will leave a visible residue on the ink stripe. (In fact, you can use a glaze of opaque pigment to change the tone of a dark area.)

A SHORT GUIDE TO TRANSPARENCY

This list gives you an idea of which common colors are opaque and which are transparent.

Transparent colors | Alizarin Crimson, Brown Madder, Burnt Sienna, Burnt Umber, Cobalt Blue, French Ultramarine, Green Gold, Hooker's Green, Indanthrene Blue, Indian Yellow, New Gamboge, Permanent Alizarin Crimson, Permanent Carmine, Permanent Sap Green, Quinacridone Gold, Quinacridone Magenta, Raw Sienna, Raw Umber, Scarlet Lake, Ultramarine Blue, Viridian

Opaque colors | All cadmiums (such as Cadmium Yellow, Orange and Red); Cerulean Blue, Indian Red, Indigo, Manganese Blue, Naples Yellow, Sepia, Venetian Red, Yellow Ochre

principles of watercolor mixing

Here are some of the basic rules that govern color mixing with watercolor.

- When you mix colors, the proportion of one to another determines the final hue and how warm or cool it is.
- The more water you add to a mixture, the lighter the value becomes.
- Colors can be mixed either on the palette, directly on the paper (wet-into-wet), or by glazing layer upon layer.
- Glazing (applying one transparent color on top of another to change the appearance of a color) can either build luminosity or dull down a color depending on the values of the colors being glazed.

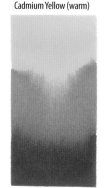

Cadmium Yellow (warm)

Winsor Blue (cool)

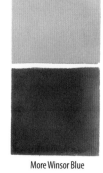

More Cadmium Yellow

More Winsor Blue

How to alter the temperature of a mixture
To change the temperature of a mixture, vary the proportions of its warm and cool "ingredients." Here, Cadmium Yellow and Winsor Blue combine to form a nice medium green. If you want a warmer green, use more Cadmium Yellow in the mix; if you want a cooler green, use more Winsor Blue.

Don't go by color names
When choosing colors to mix, remember that paints with the same name aren't necessarily the same color, as you can see in these swatches of Quinacridone Gold.

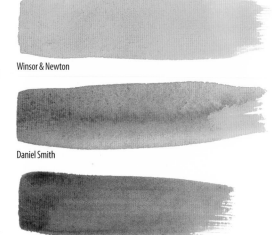

Winsor & Newton

Daniel Smith

Sennelier

24

HOW TO KEEP COLORS CLEAN

To keep your washes vibrant, clean and clear, remember these guidelines:

- Don't mix more than two or three colors at a time.

- Limit the mixing of opaque and sedimentary colors; these tend to get muddy quickly.

- Don't use an opaque color over a darker color.

- When glazing, make sure the previous layer is completely dry before applying the next layer, or you might accidentally lift the previous color, causing unwanted mixing.

- Use quality paper. Many student-grade papers do not hold color well, meaning your attempts to layer may lift color and cause mud.

- Avoid unnecessary pencil lines when drawing on your watercolor paper. The graphite can mix with the watercolor and make a painting look muddy. Simplify your line drawing and keep erasing to a minimum or not at all.

color mixing chart

This could be your lightbulb moment. Work one row at a time so you have several puddles of a tube color on the palette, ready for mixing. Charts are both useful and beautiful. You may want to post yours in your studio. If you don't have room to do that, you can paint your charts at a size that will fit in a file folder.

MATERIALS

Paper | 140-lb. (300gsm) cold press

Brushes | No. 12 sable/synthetic round or ½-inch (12mm) flat

Pigments | Any or all of the colors in your palette

Other | Ruler • Waterproof ink pen or fine-point permanent marker

1 Create the grid
With a waterproof pen, make a grid of 1-inch (3cm) squares on watercolor paper. Add a row of smaller boxes across the top and another down the left side.

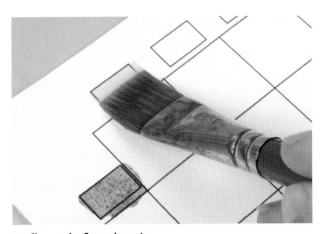

2 Choose the first color pair
Decide which two pigments you want to mix first. Dilute each with enough water to achieve transparency, then paint them into the first two small boxes at the upper left.

25

3 Mix the colors
Mix the two colors from step 2 on your palette, along with enough water to achieve transparency.

4 Add the mixture to the chart
Apply the mixture from step 3 to the corresponding square of the chart.

5 Continue
Add more tube colors to the chart and label them, keeping warmer and lighter colors on one side of the chart, cooler and darker colors on the other side. Place each mixture into the corresponding chart square. Use any of the colors you have on hand or pick from one color family at a time.

Endless possibilities
Mixing can generate almost limitless color variations. You can choose to stay within one hue, mix a variety of colors within one chart, or experiment within one color family.

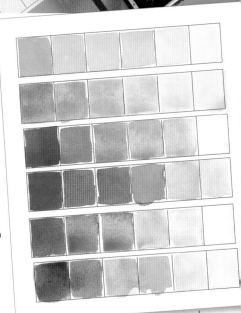

You don't need many pigments
By slowly adding more and more of the darker color to the lighter one, you can mix a wide variety of hues with only two colors.

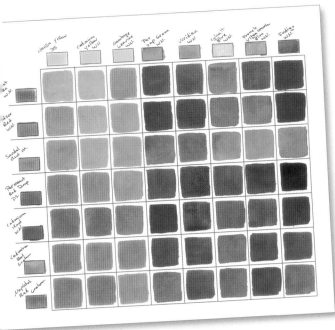

Color proportion charts
On a piece of watercolor paper, create rows of 1-inch (3cm) squares. Choose two pure colors for each row. Place the pure lighter hue on the left end of the row and the pure darker one on the right end. Gradually mix the darker color into the lighter one a bit at a time. As you increase the amount of the darker color, place each new mix into the next square, working from left to right. Charts like these can show you the wide variations possible with just two colors.

Value charts
Progressively dilute a mixture with water and paint a chart that shows a range of values.

gray, black and white

In true transparent watercolor, one never uses black or white pigments. The watercolorist's "white" is the white of the paper, and light colors are light because the paper surface reflects light up through layers of transparent color. Darks are achieved by mixing and layering rather than by using black. Tube black will deaden your painting and make your colors look flat. Instead, use other dark colors or mixtures of French Ultramarine, Burnt Umber or Indigo. Try it and see what works for you.

Indigo Payne's Gray Lamp Black

Alternatives to black

Compare these darks—doesn't the black look flat? Notice how the Indigo and Payne's Gray are more lively. Dark blues and grays are rich alternatives to black and can help a painting look more full-bodied.

MIXING GRAYS

To create neutral grays, use the magic of complementary colors (any two colors opposite each other on the color wheel [see page 21]). Mixing complements in equal proportions will make a neutral gray.

Complements make rich grays

Mixing complements (that is, any two colors opposite each other on the color wheel) makes a neutral gray.

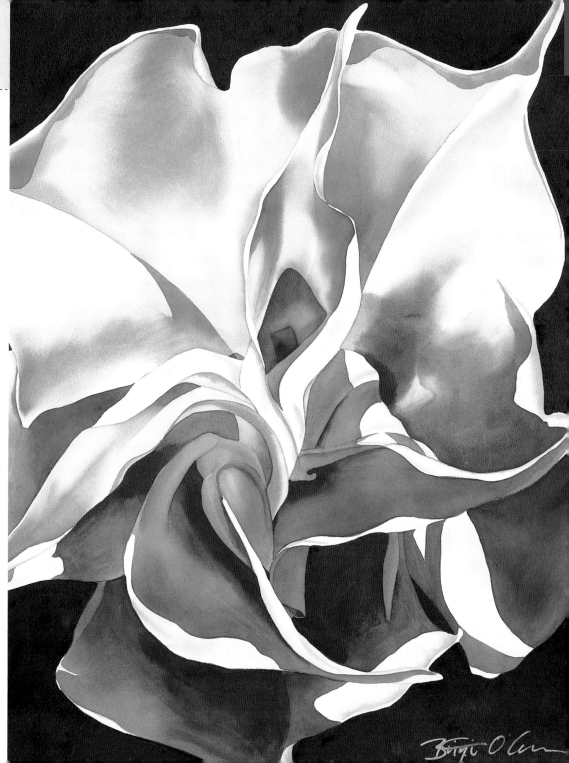

Create subtle value transitions

Gray color variations, created using combinations of French Ultramarine, Burnt Umber, Burnt Sienna, Yellow Ochre and Indigo, give this flower shape and dimension while offsetting the highlighted white areas of the paper. The subtle value transitions, along with the dramatic shadows, help pull the lightest areas forward, while the darkest darks push the background away, giving the flower drama and depth.

LITTLE SHIVA
22" × 15" (56CM × 38CM)
WATERCOLOR ON 140-LB.
(300GSM) COLD PRESS

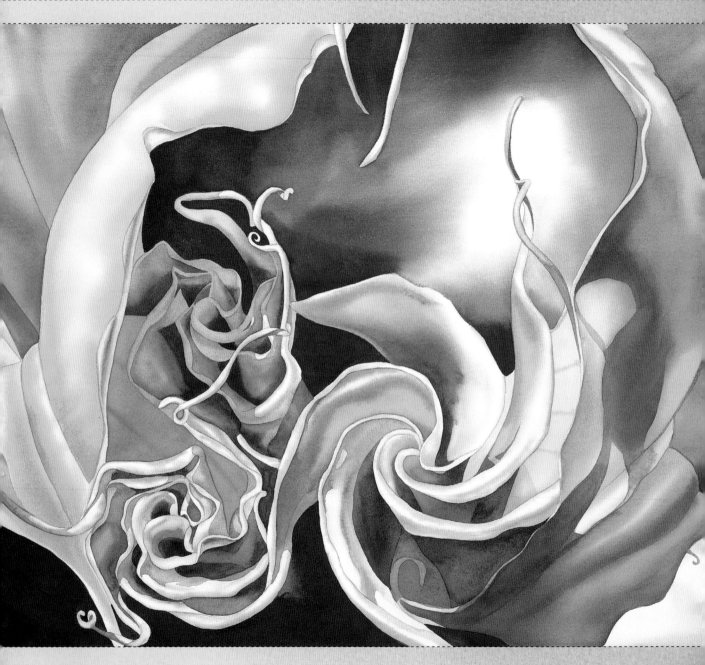

the movement of **water and color**

3

Many people feel as if watercolor is uncontrollable, but once you understand how using the right amount of water can help you have more control over the medium, you'll have more fun with it. Watching the colors blend and flow together gives you the feeling you are creating magic.

It doesn't matter what your subject is—the same use of water and movement of color creates soft, blended color transitions. Using an ample amount of water helps create natural highlights and gives spontaneity to the composition.

Let water move your pigment

Using water to flow pigment allows changing values to make the painting more interesting. Use multiple values in the shadows to provide more depth. Here, I allowed the pigment to really flow to help portray this unfolding bud in a different perspective.

PINWHEELS IN THE DARK
22" × 30" (56CM × 76CM)
WATERCOLOR ON 300-LB. (640GSM)
COLD PRESS

31

the laws of watercolor motion

Watercolor is pigment suspended in a water-soluble vehicle or base (usually gum arabic). When mixed with water, the pigment particles can spread out across the page. You control how the pigment bends and flows by regulating how much water you use. Here are the basic rules of how watercolor moves.

1: COLOR CAN'T MOVE WITHOUT WATER.

Color applied to dry paper stays within the area of the stroke; it cannot move beyond the wet area and into a dry one unless pushed (or unless there is a puddle and the paper is held at an angle).

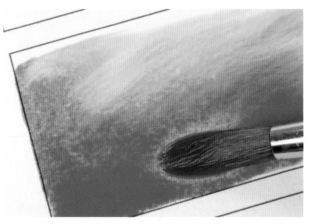

When color is applied to wet paper, it moves more easily and blends quickly, leaving a more luminous appearance. Learning how much water to use is a matter of practice.

2: DIFFERENT COLORS MOVE DIFFERENTLY.

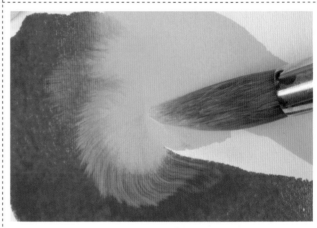

Some colors , such as Cadmium Yellow (shown here) and Cobalt Blue, tend to "explode" across the surface.

Other colors spread more slowly. Carbazole Violet and French Ultramarine, for example, being sedimentary colors, are heavier and settle quickly onto the surface.

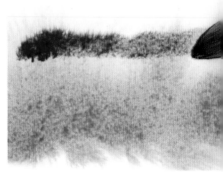

3: BACKWASHES HAPPEN WHEN THE MOISTURE LEVEL IS UNEVEN.

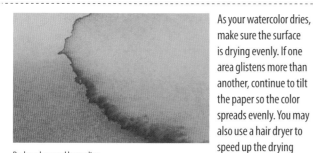

Backwash caused by pooling

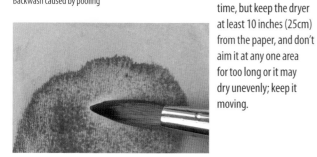

Backwash caused by adding color to a damp area

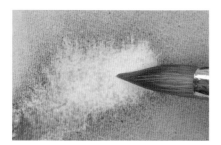

Backwash caused by adding water to a damp area

As your watercolor dries, make sure the surface is drying evenly. If one area glistens more than another, continue to tilt the paper so the color spreads evenly. You may also use a hair dryer to speed up the drying time, but keep the dryer at least 10 inches (25cm) from the paper, and don't aim it at any one area for too long or it may dry unevenly; keep it moving.

4: WATERCOLOR CAN BE LIFTED TO VARYING DEGREES.

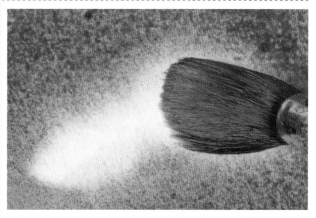

To remove color from a damp area, use a clean, damp brush to lift it out.

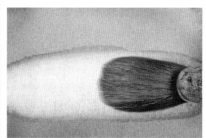

To remove color from a dry area, reapply water to the area. Let it sit, then lift the color out with a clean, damp brush or paper towel.

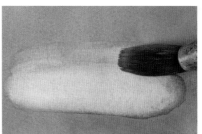

Once an area has dried, reapplying water will lift color but can leave a noticeable water line. If this happens, you can try to soften the edges with a clean, semidamp brush.

EXERCISE

blending color

Do this blending exercise to gain an understanding of how water and color move. In an actual painting, you'll blend colors the same way; the only difference will be that instead of doing it in a rectangle, you'll do it within a shape in your composition.

In general, using the largest brush possible to apply water to an area, then switching to a separate brush size for the area you're painting, will help you achieve soft color transitions.

MATERIALS

Paper | 8½" × 11" (22mm × 28mm) or ¼ sheet 140-lb. (300gsm) cold press

Brushes | 1-inch (25mm) natural-hair mop • No. 30 natural-hair round or bamboo hake • No. 14 sable/synthetic blend round

Pigments | Any colors from your palette; you might refer to your color charts (page 25) to find combinations you like.

Other | Ruler • Waterproof pen or marker

1 Draw a grid and wet the first rectangle
Draw several rectangles on your paper, leaving a bit of space between them. Prepare puddles of two colors on your palette.

Use your large natural-hair mop to fill the first rectangle with clean water. There should be enough water to flow easily when the paper is tilted.

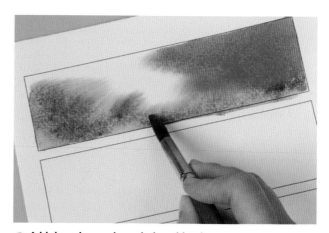

2 Add the colors and watch them blend
While the surface still glistens, use your no. 14 sable/synthetic blend round to place one color on each end of the rectangle, leaving room between them for color to travel. Use your brush to direct the flow and control the edge. Once you are satisfied with the effect, proceed to step 3.

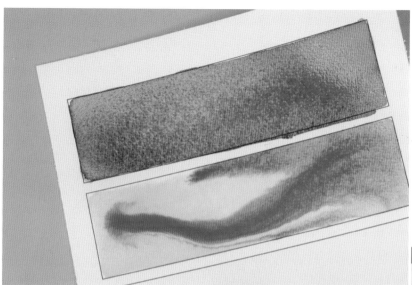

3 Repeat, blending the color with water

Wet the second rectangle and apply color as in step 2, except this time, immediately tilt the paper and notice how the color blends. The amount of movement and blending will be determined by the amount of water on the surface. Notice how the color moves only within the wet areas and not beyond unless it pools and the paper is tilted. This is one of the fundamental techniques for achieving smooth blending and natural transitions.

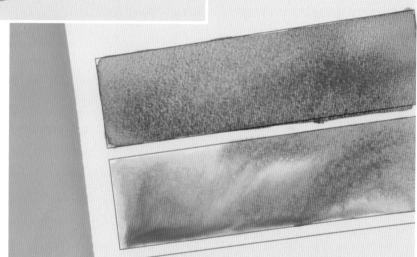

4 Remove any pools

If pooling occurs, use a clean, damp, natural-hair round to blot and soak up the excess water. This will prevent backwashes from forming as the paint dries.

5 Do another, and another

Continue to experiment with this water-and-color technique so you become comfortable with how much water to use and how to direct the flow and movement of color. Try different colors, tilting angles and drying times.

the flat wash

A flat wash is an even layer of color that is the same value throughout.

Traditionally, a flat wash is applied to either damp or dry paper. A much more forgiving technique to achieve the same result is to first apply enough water to make the paper glisten, then apply the pigment. Using the right amount of water in the beginning allows you more time to work. Using the right type and size of brush is also critical to success; otherwise the color may dry more quickly than you can work, creating unwanted brushstrokes.

MATERIALS

Paper | ¼ sheet 140-lb. (300gsm) cold press

Brushes | No. 30 natural-hair round

Pigments | Winsor Blue

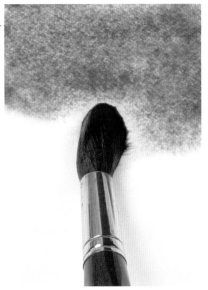

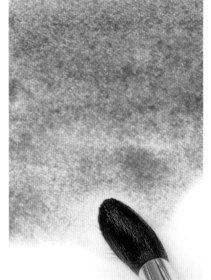

1 Wet the paper and begin applying color

Wet the entire paper so the surface glistens evenly. Apply color, working from top to bottom, back and forth, in long, sweeping, overlapping strokes. Once color is applied, do not rework it or you will ruin the evenness of the wash.

2 Work your way down the paper

Continue applying strokes until you reach the bottom of the area.

3 Lift and tilt

Working rather quickly, so no one area dries faster than another, lift and tilt the paper from side to side to even out the color.

Let the paper dry flat. This will keep the color from gravitating toward any one area. Remove excess water along the edges with a clean brush or paper towel as needed to prevent unwanted backwashes.

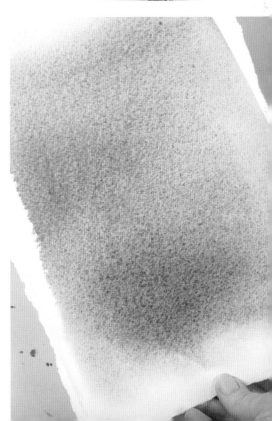

the gradated wash

In a gradated wash, the color lightens gradually from the begin-ning of the wash to the end.

Use this technique for any area where you want to show transitional value or gradual blending of color, such as creating the appearance of form in a shape or adding atmosphere or a sense of distance to a landscape.

MATERIALS

Paper | ¼ sheet 140-lb. (300gsm) cold press

Brushes | No. 30 natural-hair round

Pigments | Winsor Blue

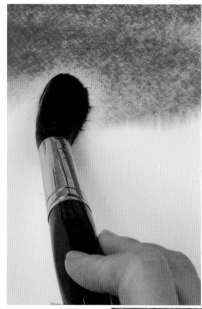

1 Wet the paper and begin applying color
Using a large natural-hair brush, wet the entire paper so the surface glistens. There should be enough water that it moves freely when the paper is tilted. Starting at the top, apply color in long, sweeping, overlapping strokes.

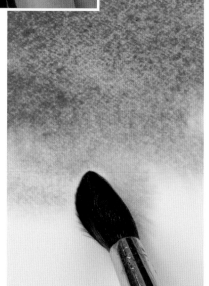

2 Work your way down the paper
Working rather quickly, continue to apply color so no one area dries faster than another. Cover approximately half of the sheet of paper with color.

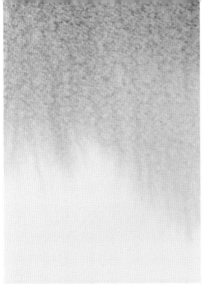

3 Lift and tilt

Once half the sheet is covered, lift and tilt the paper from top to bottom and allow the color to run back and forth. The amount of water you applied at the beginning will move the color and help eliminate any unwanted brush marks. If more water is needed, apply it to the entire area with a soft brush; don't stop short, or unwanted backwashes may appear. Then allow the color to rest and settle at one end. Wherever the color rests will be the richest saturation. Your composition will determine where you want that rich saturation or deepest color to be.

4 Remove the excess water

Once you are satisfied with the gradation of color, allow the excess water to run off the paper. Then rest the paper at a thirty-degree angle to continue the movement of color or lay flat to dry. Remove any excess water along the edges with a clean brush or paper towel to prevent unwanted backwashes.

5 Let dry, then evaluate

Let the paper dry. Watercolor can dry up to two times lighter. If the dried wash is too light, apply multiple layers to achieve the desired color saturation or density.

problems with washes

Wash problems are common, but if you understand their causes, you can do a lot to prevent them.

BACKWASHES

These occur when two areas have different amounts of moisture, causing color to move unevenly. To prevent backwashes:

- Avoid adding more color to damp areas (wait until they are dry).
- Avoid hot-pressed paper when you want really smooth washes, and be sure to use high-quality paper rather than student grades.
- Use paper that is 300-lb. (640gsm) or heavier. Lighter weights tend to buckle, which leads to pooling and backwashes.
- Use a hair dryer to speed up the drying process, but keep it moving, and hold it at least 10 inches (25cm) from the paper.

Backwashes
Backwashes happen when the moisture level is uneven.

VIDEO | Problems with washes

Removing excess water to avoid backwashes
If paint pools, soak up the excess with a paper towel or the tip of a clean, damp, blotted natural-hair brush.

STREAKY WASHES

Using too many brushstrokes can make a layer uneven by lifting and pushing pigment around and can even damage the paper. Use larger brushes to minimize brushstrokes, and avoid overly stiff synthetic brushes.

Streaky washes
Stroking back and forth too much or using too small a brush can cause streaks. Some overly stiff synthetic brushes can also do this.

HARD-EDGED WASHES

When water is reapplied to an area before it is completely dry, diluted pigment lifts from the center and settles around the edges, leaving an unintended hard line.

Hard-edged washes
Reapplying color to an area that isn't completely dry can cause a hard ring to form along the edge of the wash.

GRAINY WASHES

Mineral pigments and sedimentary colors are unlikely to give you smooth washes (see page 22, Granulation). Graininess can also be caused by dust particles settling on an uncovered palette. (Keep your palette clean!)

building color with layers

Value contrast gives a painting depth; lots of contrast can make a painting very dramatic. Watercolor will always lighten as it dries, so multiple layers are usually needed to build rich color.

Some watercolorists apply up to one hundred layers, but that is incredibly time-consuming; really, you can accomplish the same color saturation in much less time with only three or four layers.

HOW TO LAYER

It's important to let watercolor dry completely before applying another layer. Once a color has had time to really dry, it bonds better with the paper, making it easier to apply the next layer. Test your initial application of color with the back of your hand: If it feels cool to the touch, it is still too damp. If you apply another layer at this time, the previous color may lift, creating streaks or mud.

Once you're sure a layer is dry, use a large, soft brush to reapply clean water to the area you are working on. Then add an additional layer only where needed. This is how you start to build color saturation with natural transitions. Using the right amount of water and building color only where needed helps you avoid hard-edged, harsh transitions and keeps your paintings from looking labored.

LAYERS:

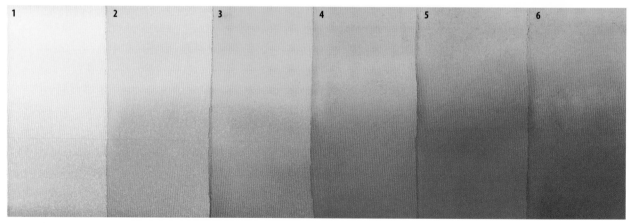

Watercolor lightens as it dries
Some watercolors lighten significantly when dry. To build the desired saturation, glaze on multiple layers as needed (letting each layer dry before adding the next).

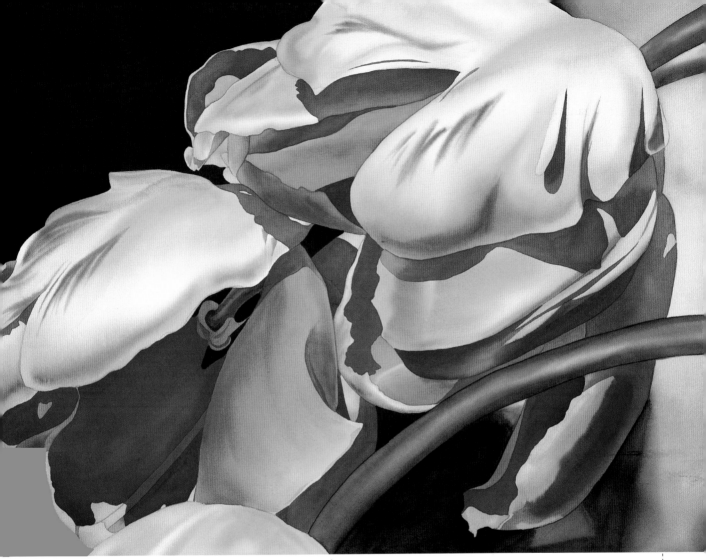

Use contrast for drama

Once the initial color has been established in a painting, multiple layers will be needed to give the impression of dimension. Second and third layers can be limited to areas where shape or shadows are needed. If your pigment application is very light, you may need more layers.

A dark background behind a light subject has great impact. The different values help give the flower the illusion of shape and depth.

DANCING TULIPS
30" × 40" (76CM × 102CM)
WATERCOLOR ON 300-LB. (640GSM) COLD PRESS

texture techniques

Sometimes a flat, boring area of color just needs a little splash of water or color or a dash of salt to liven it up. You can use texturing techniques to create the impression of mottled or dappled light in a background, add color variation to a flat area, increase the degree of detail in the foreground, or add points of interest.

Texturing with salt

Consider salt for areas where you need something unusual, such as backgrounds, rocks or any area that needs texture. Add salt as the color is drying but while the paper is still damp. The effect will vary depending on how wet the paper is and what kind of salt you use. Try table salt, kosher salt, rock salt or sea salt; each has different-sized granules and will create slightly different results. The best one to use will be a personal choice.

Texturing with water or paint (spattering)

You can create texture quickly with clean water or paint. As an area is drying, gently tap a small brush loaded with water or paint to spatter water or color onto the surface. How far the spattered liquid will spread is determined by how damp the surface is. Don't apply too much water or color at one time, or the area can become too wet and the effect will be lost. For softer, more natural edges, lift the paper and tilt it to move the color around.

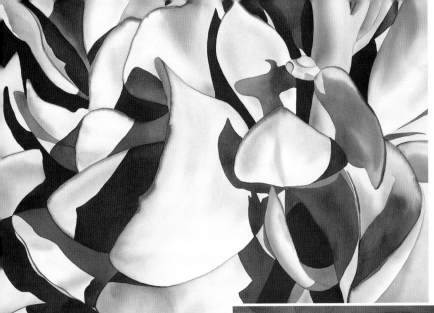

Spattering with blending

The thick, broad petals of succulents are an especially good subject for spattered texture. The additional color helps to break up the sameness of an area. Here, the spattering has been softened so it is more subtle and blends more into the painting itself.

THE MASK
30" × 40" (76CM × 102CM)
WATERCOLOR ON 300-LB. (640GSM) COLD PRESS

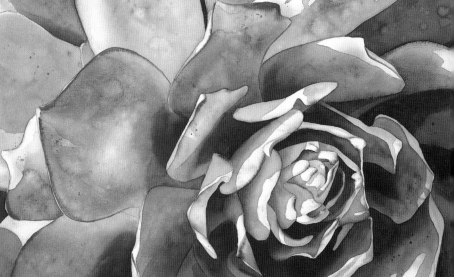

Spattering without blending

In this painting, I spattered water on petal areas that were almost dry, creating small, intentional back-washes. Then I left the painting to dry without lifting the paper to blend the colors. This resulted in more texture and noticeable contrast between colors.

PURPLE SUCCULENT
22" × 30" (56CM × 76CM)
WATERCOLOR ON 300-LB. (640GSM) COLD PRESS

edges

An edge is where one area ends and another begins. Edges give definition and clarity to a painting. The types of edges you create—soft, hard, wet-into-wet, overlapping—can reveal how much control you have over the medium, and they affect the entire feel of a painting.

Single value equals flat
Using one value of color all the way to the edge of a shape can make an image look flat.

Overlapped edge
Color glazed over a dry edge creates a third color between the edge and center colors. This can distract from the clarity of a painting.

Color next to color
Here, the edge color was painted alongside the first color once the first color was dry. This creates a distinct separation between them.

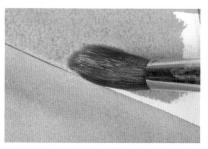

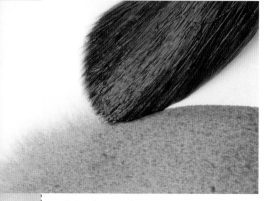

Softening an edge
As a shape is starting to dry, use a large, clean, damp brush to release and pull some color to soften the edge.

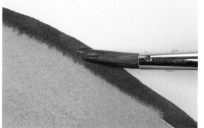

Blended edge
Here, I blended color onto an edge that was still drying. The combination of a distinct edge color and a blended transition gives one side a softer appearance, while the clean, crisp line shows clarity.

How to create the blended edge
While a shape is still damp, use a slightly damp (but not wet) no. 14 or 20 natural-hair or sable/synthetic blend round to define its edge. Apply the edge color to the dry paper just outside the edge of the damp shape, allowing the color to touch and run back into the damp area.

EXERCISE

hard and soft edges

See the DVD to follow along with the beginning of this exercise. It will familiarize you with blending color within a shape and adding an edge line and texture. By using a complementary color along the edge, you can enhance a painting and make it more interesting. Varying values and creating interesting shadows can make even the simplest composition dramatic.

MATERIALS

Paper | ¼ sheet 300-lb. (640gsm) rough press

Brushes | 2½-inch (6cm) bamboo hake
• No. 30 natural-hair round • Nos. 8 and 20 sable/synthetic blend rounds • No. 8 synthetic round

Pigments | Burnt Sienna • Burnt Umber • Emerald Green • French Ultramarine • Indigo • Naples Yellow • Permanent Alizarin Crimson • Sap Green

Other | Graphite pencil

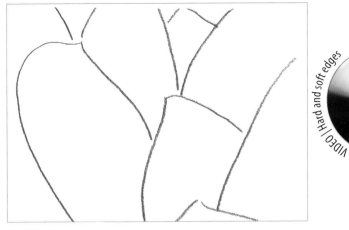

Line drawing
Sketch this line drawing on your watercolor paper to get started. After you've done your line-drawing work, fill one petal at a time with clean water using the largest brush, then add color using one of the midsized brushes. To make it more interesting, spatter one or two additional colors and allow it all to blend.

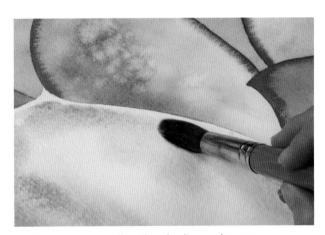

1 Apply color, controlling the edge line, and spatter
See the DVD to apply color to the petal, leaving a dry space between the main color and the pencil line. Allow the pigment to dry a little. Then spatter (page 44) with Permanent Alizarin Crimson and French Ultramarine.

47

2 Create multiple effects

Using a no. 8 synthetic round while the petal color is still damp but not wet, apply Permanent Alizarin Crimson along the pencil line, touching the petal color. This creates a clean line on one side and a soft transition on the other.

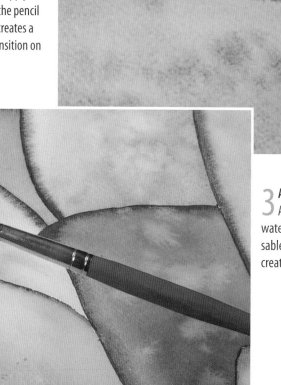

3 Add more texture

As the petals dry, reapply a spattering of water or color using a light touch and no. 8 sable/synthetic blend round if you want to create more texture.

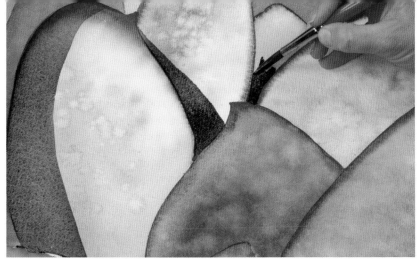

4 Add dark shadows
Once all the color and texture has been applied, let dry. Then add the hard, dark shadows to give the image definition and depth. Once you add all your shadows, reevaluate. If you notice areas that don't seem dark enough, add additional layers of pigment.

SUCCULENT LEAVES ▼
15" × 22"(38CM × 56CM)
WATERCOLOR ON 300-LB. (640GSM) ROUGH PRESS

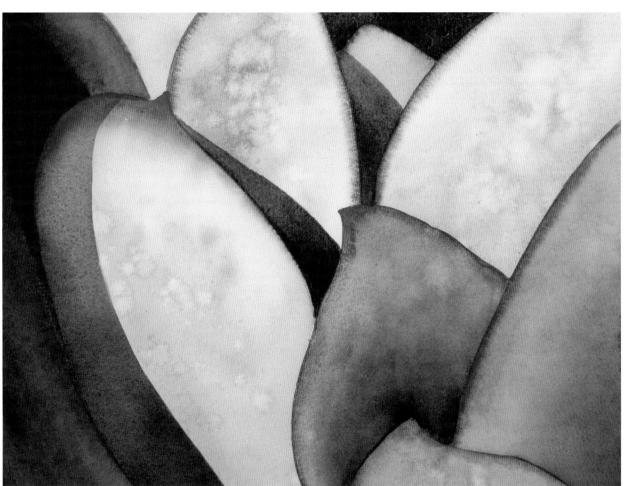

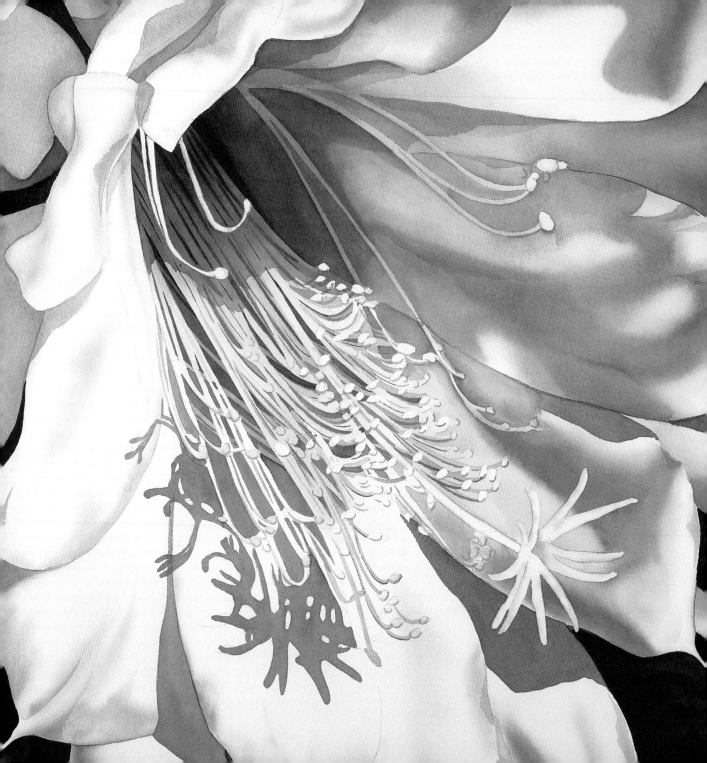

value

At first glance, most people don't really notice how different the values in a subject can be; they just think in terms of "light" and "dark." But between those, there is an infinite number of subtle value changes. Capturing some of that subtlety is critical to creating depth in a painting. Without those transitions of value, an image would appear flat.

In this chapter, you'll learn easy ways to determine value changes and apply them to your paintings. And you'll learn to use simple designs and value changes to create the illusion of shape.

Changing values

Using different degrees of value changes the appearance of a painting and gives it more depth. Notice how the darker values in the shadows draw you into the flower, while the lighter ones seem to lift and give shape to the other petals.

STAR BLOOM
30" × 22" (76CM × 56CM)
WATERCOLOR ON 300-LB. (640GSM)
COLD PRESS

observing values

When you are working on a painting, break down into three groups the shapes you see in your reference material: light, medium and dark. Next, notice the more subtle changes within these areas that may have eluded you at first. When you make a habit of doing this, you will start to see that areas that may have appeared to be only one value actually contain many different values. You will also notice that not all shadows are the same.

TRICKS FOR FINDING VALUES

- When outside in nature, try viewing the scene or subject through a piece of red film acetate (found at photography shops) or red mylar (available through craft suppliers). The red will remove all color from the scene, leaving behind only the variations of lights and darks.
- When painting from photographs, consider making a black-and-white print or a photocopy of the photo. Eliminating the color makes it much easier to see the value changes.
- If neither of the above methods is available, simply squint your eyes. This minimizes details and forces you to see only the basic shapes and color.

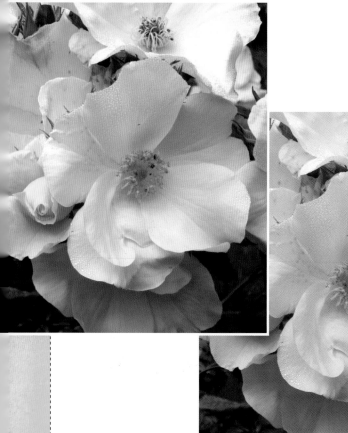

Color vs. black-and-white photo

Making a black-and-white print or photocopy of a reference photo can help you see the subtle value changes and can make it much easier to identify where to apply the light, medium and dark values in your paintings.

Here, I printed out a digital photo in both color and black and white. This helps give you a better idea of what the values are by removing the distraction of color. You can also just use a photocopier to copy your color photo in black and white.

value scales

In watercolor, it is simple to lighten the value of a pigment: You just increase the water-to-pigment ratio. For a darker value, use more pigment and less water. Values give a painting shape and depth, so it is important to internalize the different value transitions available.

Adding water to watercolor paint also makes the paint more transparent—the quality that gives watercolor its unique beauty. If you don't use enough water, the color will look more opaque, which can result in a flat-looking painting.

In this exercise, you'll get a feel for how much water to mix with your paint and how values change and color becomes more transparent with the amount of water used.

MATERIALS

Paper | 8½" × 11" (22cm × 28cm) or ¼ sheet 140-lb. (300gsm) cold press

Brushes | ½-inch (12mm) nylon flat

Pigments | Any colors from your palette

Other | Permanent marker or pencil • Ruler

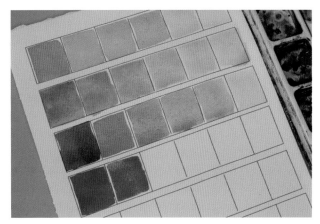

Keep values in a grid
Make a grid of 1-inch (3cm) squares with six squares across and six down. In the first square in the first row, place a color at full strength. In the next square across, paint the same color diluted with a little more water. Continue across, adding more water as you go. Dilute the color more with each step until it is almost transparent.

Lighter pigments, more water
Notice how much water is used while mixing colors. As you add more and more water to the palette, the colors gradually lighten.

53

how values work in paintings

Values work differently in a painting depending on the subject. A darker background in a floral painting brings the highlights forward, giving the impression that one can almost touch or enter a still life. In most landscapes, the opposite is true: Darker colors in the foreground help ground the painting so the lighter values give you the feeling of moving off into the distance.

Dark backgrounds move florals forward

Notice how the different values help to give the image shape, while the harder lines of the shadow help lift the center away from the rest of the flower. The intensity of the dark background adds mystery, drama and depth.

All the tones were created with different combinations of French Ultramarine, Burnt Umber, Burnt Sienna, Yellow Ochre and Indigo. The illusion of the painting is created with value, not color.

ANGEL DANCE
30" × 40" (76CM × 102CM)
WATERCOLOR ON 300-LB. (640GSM) COLD PRESS

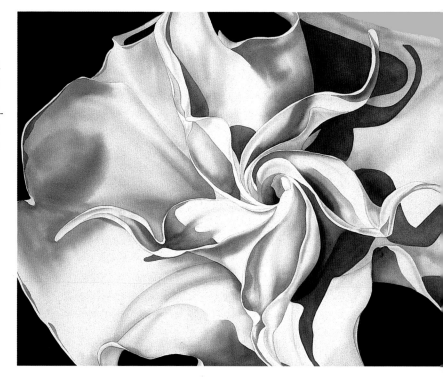

54

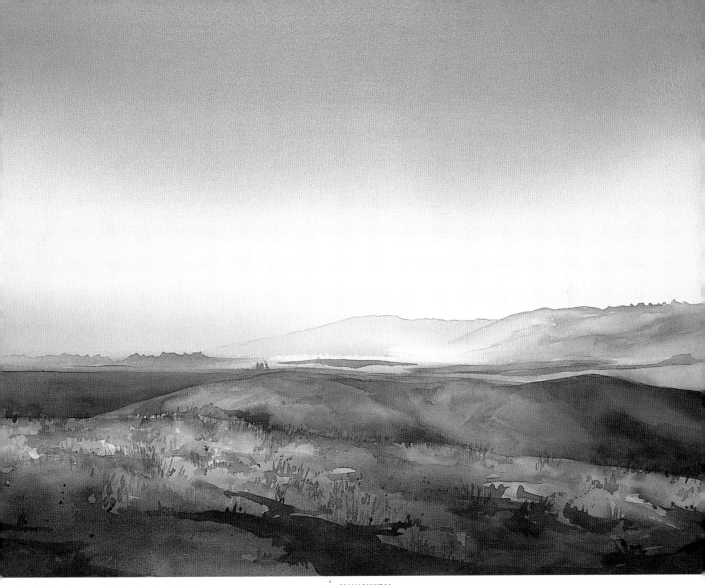

Darks in a foreground give depth to landscapes

This landscape painting contains all the same colors as the white flower painting on the facing page, with the addition of Permanent Alizarin Crimson and New Gamboge. The darks in the foreground give the viewer a starting point; the medium values lead the eye out toward the lightest values in the distance.

COMMONWEAL
22" × 30" (56CM × 76CM)
WATERCOLOR ON 300-LB. (640GSM) COLD PRESS

create shapes with values

On page 53 you learned how to change the value of a color by adding water. Now use that knowledge to model a simple shape. You'll discover how, all by themselves, values can create the appearance of depth and roundness.

MATERIALS

Paper | 11" × 15" (28cm × 38cm) 140-lb. (300gsm) cold press

Pigments | Burnt Umber • French Ultramarine (or a single color such as sepia, blue or gray)

Brushes | Large natural-hair brush such as a mop or a no. 30 round • No. 8 synthetic or sable/synthetic blend round

Other | Compass or 4" (10cm) circle template, a lid, or the bottom of a jar • Graphite pencil • Ruler

1 Get ready
With a pencil and a ruler, draw several 5" (13cm) squares. Six of them fit on an 11" × 15" (28cm × 38cm) piece of paper. Inside each square, draw a circle about 4" (10cm) in diameter.

On your palette, mix French Ultramarine and Burnt Umber into a neutral gray (or use a single tube color such as a sepia, blue or gray).

2 Paint a circle
Using a large natural-hair brush, wet one circle with clean water (the paper surface should glisten so the color can move). With a no. 8 round, place a stroke of color halfway around the top, then place another stroke slightly above the bottom. As the color dries, it should blend into the clean water to create a soft edge. If needed, tilt the paper to direct color to blend the edges.

3 Add a background
When the circle is thoroughly dry, paint a background using the same color in either a solid or a gradated wash (pages 37–39).

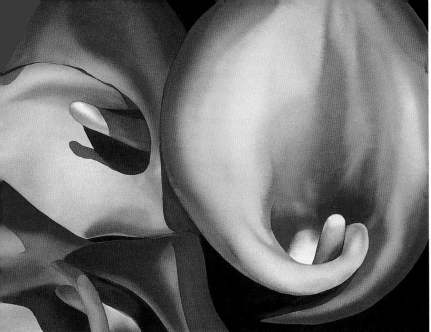

Value principles at work in a painting
The gradual transitions and the darker center in this flower invite the viewer in. The darker color around the edges of the petals make the flower contrast with the highlights and appear to fold over.

MEDITATIONS ON COLOR
22" × 30" (56CM × 76CM)
WATERCOLOR ON 300-LB. (640GSM) COLD PRESS

Place a stroke of color around the top or just above the bottom to give the impression of reflected light, which will suggest form.

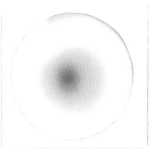

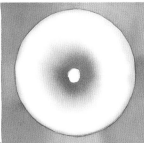

Gradual transitions and values from light to dark lead to and from the center of the object and pull you into an object's center.

4 Paint more circles
Paint the other circles one at a time. Try different stroke placements and background washes to see how they affect the apparent depth and contour of the shape. Try using values to make a circle look as if it's indented, floating, folding over or peeling away.

Your placement of background values can make the ball look as if it is resting on the ground . . .

. . . or floating on air.

57

about cast shadows

Cast shadows are crucial to the illusion of depth in a painting. A cast shadow with well-placed value transitions and well-defined edges can enhance the drama and power of an image.

The value of a cast shadow depends on the time of day, how much light is able to reflect into the shadow area from nearby surfaces, and how much light can penetrate through the image. Shadows usually aren't just one value; they contain transitions of value. Your paintings will be much more interesting and have more depth if you observe and re-create these transitions.

Shadows aren't just one value
The darkest area underneath this sphere is where the least amount of light is able to reach. As the shadow gets farther from the object, it becomes lighter because more ambient light is able to bounce into the shadow area.

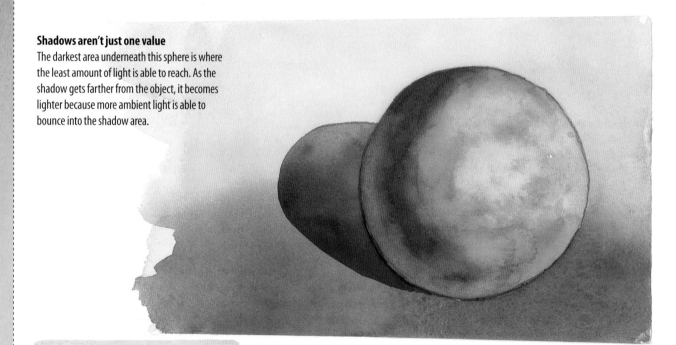

REMEMBER
A cast shadow is always on the side of the object opposite the light source.

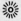

Use value change within cast shadows

In the areas where the subject is most dense, the shadow will be the darkest. As more light is able to penetrate, value slowly transitions from dark to medium to light. The combination of different values, shadows, and hard and soft lines helps to define depth, allowing the petals to separate and appear as if they're lifting off the page. Notice the subtle value changes that occur in the shadow that one petal casts onto the other.

APRIL MOON
22" × 30" (56CM × 76CM)
WATERCOLOR ON 300-LB. (640GSM) COLD PRESS

create form on a single pear

Start with this simple composition of pears; doing so will help you get comfortable with the amount of water and pigment needed to create a range of values to suggest form.

MATERIALS

Paper | ⅛ sheet of 140-lb. (300gsm) cold press

Brushes | Large natural-hair brush such as a 1-inch (25mm) mop, no. 30 round or 2½-inch (6cm) bamboo hake • Nos. 8 and 20 sable/synthetic blend rounds

Pigments | French Ultramarine • Indigo • Permanent Alizarin Crimson • *Quinacridone Gold • Sap Green • Yellow Ochre

Other | Graphite pencil

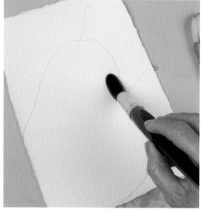

1 Sketch and apply water
Sketch a very simple composition of a single pear. Using your large natural-hair brush, fill the inside of the pear almost to the pencil line with clean water, reserving a few dry areas in the center to be future highlights.

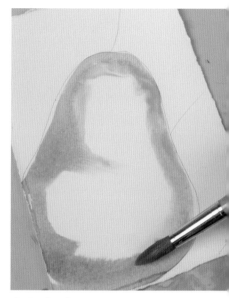

2 Apply color
Using a no. 20 sable/synthetic blend round, mix a combination of Yellow Ochre and Quinacridone Gold. Still using the no. 20 round, apply color along the edge of the water right up to the pencil line; then allow the color to run back into the clean water. The amount of water used will determine how well the color will flow.

PREVENT UNWANTED BLOSSOMING

To prevent any unwanted blossoming, lift out the excess water with the tip of your brush or a paper towel.

*If Quinacridone Gold is unavailable, use Yellow Ochre or Raw Sienna.

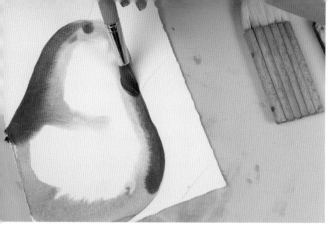 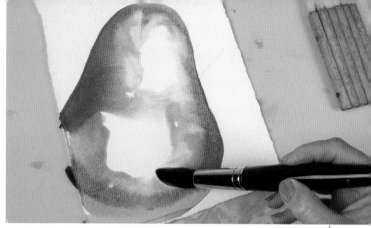

3 Mix color on the paper

While the surface still glistens and the color is damp, apply a little Permanent Alizarin Crimson on the sides and just above the bottom of the pear. In the center of the wet surface, add just a touch of Sap Green to make the color more interesting.

4 Soften the edges

To help soften the edges, use a large natural-hair brush to add more water along the edges of the color so it can blend and move freely.

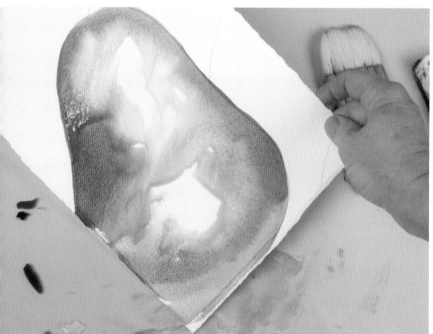

5 Move the color

For optimum blending, lift the paper and allow the colors to naturally flow together; the amount of water used will determine how well the color will blend. Once you're satisfied, allow this layer to completely dry before applying the next layer.

WHY WE AREN'T USING A BOARD

Lifting and tilting the paper to allow pigments to mix naturally is a very tactile experience. It would be difficult to cup the paper if the painting was attached to a board. It is important to feel how the water and color flows. And 300-lb. (640gsm) paper doesn't buckle as easily as lighter papers.

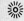

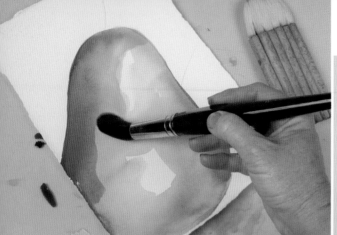

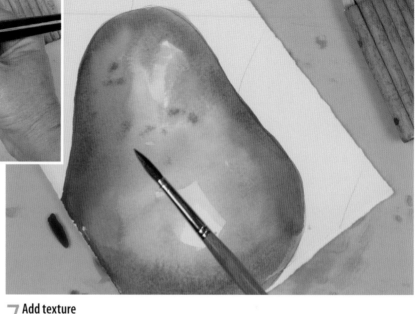

6 Apply the second layer

Once dry, apply the second layer using the same color combination, following the placement of color where you applied the first layer.

For the richest saturation, apply a loaded brush directly to dry paper, then soften the edges immediately using a large natural-hair round. Then pull out the edge of the color with clean water. Apply as many layers as needed to achieve the desired results, allowing each one to dry before applying the next.

7 Add texture

Prevent the image from looking flat by using your no. 8 sable/synthetic blend round to spatter just a touch of Sap Green or clean water onto the drying color. The wetter the surface, the more disbursed the spatter will be; the drier the surface, the more defined the spatter will be.

8 Create the stem

Still using the no. 8, hold the brush loosely, higher up the handle, then apply the stem. This doesn't have to be perfect; keep it simple. In fact, if you try too hard, it won't look as good.

9 Add the shadow

For the darkest color in the shadow, use Indigo or a mix of Indigo and French Ultramarine. Wet the shadow area and apply the pigment just under the pear. As the color moves out toward the edge, lighten the value by adding more water. The combination of the complementary colors helps to enhance both colors, giving each more life and vibrancy.

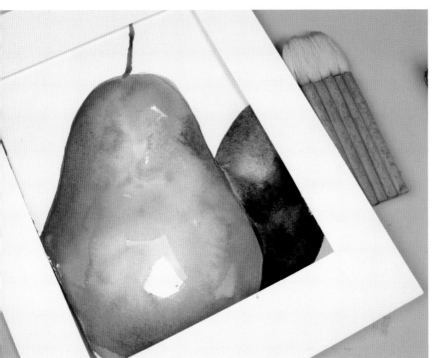

10 Know when to stop

To finish it off and tie together the background and foreground, add only a touch of the same mixture of French Ultramarine and Indigo to the sides and just under the pear. Then wash it out into the rest of the image with clean water. This will help to add more shape and dimension and the impression of a shadow. Keep yourself from overworking it by placing a mat around it, stepping away for a moment, then taking another look at the piece. You will be surprised to see how different it looks.

> ## STEP AWAY
>
> Remember to step away from your painting for a moment or place a mat around it to get a fresh perspective. This will help prevent you from overworking the piece.
>
>

create form and shadows with three pears

Treat the three pears the same way you did the single pear. Using three simple shapes forces you to push one back and pull one forward. Using different values in the shadows will help lift the pears off the paper.

MATERIALS

Paper | ½ sheet 140-lb. (300gsm) hot press

Brushes | Large natural-hair brush such as a 1-inch (25mm) mop, no. 30 round or 2½-inch (6cm) bamboo hake • Nos. 8 and 20 sable/synthetic blend rounds

Pigments | French Ultramarine • Indigo • Permanent Alizarin Crimson • *Quinacridone Gold • Sap Green • Yellow Ochre

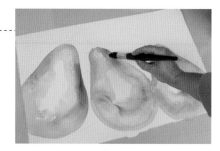

1 Sketch and apply water and color
Follow the basic steps for the single pear exercise (pages 60–63) to paint the three pears. Using the same colors, apply water to the insides, leaving only a small dry area in the center; then apply the color, working one at a time.

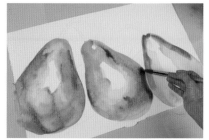

2 Continue layering
To keep your colors clean, allow each layer to completely dry before applying the next. Continue until you're satisfied with the saturation.

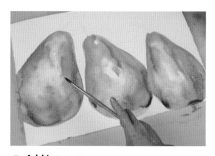

3 Add interest
While the surface is still damp, use a no. 8 sable/synthetic blend round to lightly spatter a few different colors for interest.

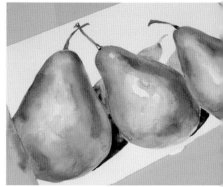

4 Finish
When the surface is almost dry, use a no. 8 sable/synthetic blend round to add the stems and shadows. Adding these while the pears are still damp will cause bleeding, leaving a loose appearance. Remember to keep the darker values on the opposite side and under the light source.

If Quinacridone Gold is unavailable, use Yellow Ochre or Raw Sienna.

create depth with value

Using a very simple composition of only few large petals, you'll learn how to blend color to create smooth washes and variations of values. The values create highlights, and a darker background helps add mystery and push the painting forward. The center gives the viewer's eye an area to focus on.

MATERIALS

Paper | ½ sheet of 300-lb. (640gsm) cold press

Brushes | Large natural-hair brush such as a 1-inch (25mm) mop, no. 30 round or 2½-inch (6cm) bamboo hake • Nos. 8 and 20 sable/synthetic blend rounds

Pigments | Indian Yellow • Indigo • Permanent Alizarin Crimson • Thioindigo Violet • Vermilion

Other | Graphite pencil

ACHIEVE SMOOTH BLENDING

Smooth blending is created by how you move the paper and the amount of water on the surface. It is important that the color can move freely.

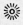

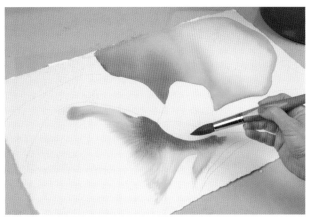

1 Begin the first wash
Draw large, abstract shapes for the petals. Starting with the largest area, use your large natural-hair brush to flood the petal with clean water almost to the pencil line. Mix Permanent Alizarin Crimson and Vermilion on your palette. While the surface still glistens, use a number no. 20 sable/synthetic blend round to randomly apply color to the petal along the pencil line, leaving white paper for highlights. Lift the paper and allow the color to run, tilting the paper to direct the flow of color. To make the highlights more interesting, add a light value of Indian Yellow. Continue around to the surrounding petals.

2 Approach the center
Using the same application of water and the no. 8 sable/synthetic blend round, apply color to the edges of the center. Leave enough white of the paper in the center so the color can run back in; this will create natural value transitions and variations.

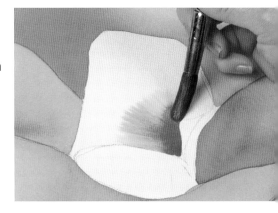

65

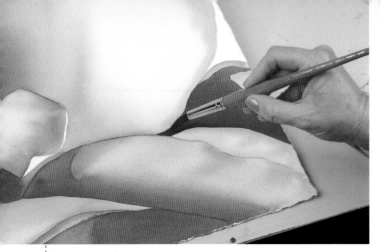

3 Reevaluate

Once all the petals have color, reevaluate. Where might you need to enhance and build layers? Which areas do you want to bring forward? Which do you want to recede?

For sharp, clean lines, apply color directly to dry paper. For darker shadows, use Thioindigo Violet or Indigo mixed into your palette color for the petal.

4 Continue layering

Use the same process to apply the second and third layers: Apply water, then pigment, then lift and tilt the paper, directing the flow of color and allowing the pigments to blend and mix directly on the surface.

5 Finish

Once you think you are done, reevaluate and determine if you need to continue building color or add more detail. You can either leave the background white or add leaves to make it dramatic.

CAN'T REACH?

Turn the paper upside down or on its side to handle the hard-to-reach areas.

※

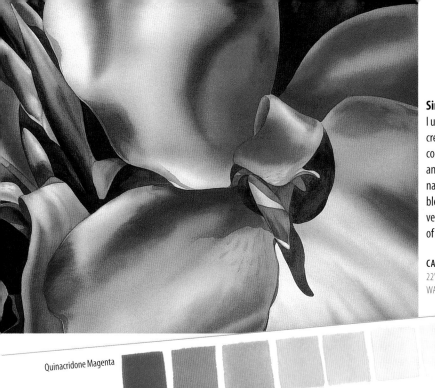

Simple techniques create dramatic results

I used the same techniques as for the exercise to create this painting. This version is just a little more complex. I applied color to the large petals, lifting and tilting the paper to enable the pigments to naturally mix with one another, creating gentle blends and transitions. The highlights are actually a very light value of the pigment reflecting the white of the paper underneath.

CANNAS FOR JANN
22" × 30" (56CM × 76CM)
WATERCOLOR ON 300-LB. (640GSM) COLD PRESS

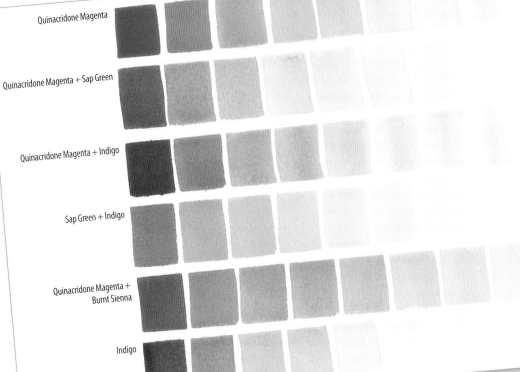

Quinacridone Magenta

Quinacridone Magenta + Sap Green

Quinacridone Magenta + Indigo

Sap Green + Indigo

Quinacridone Magenta + Burnt Sienna

Indigo

Pigments and values used in *Cannas for Jann*
Notice how a pigment's value can change with the amount of water used and its application.

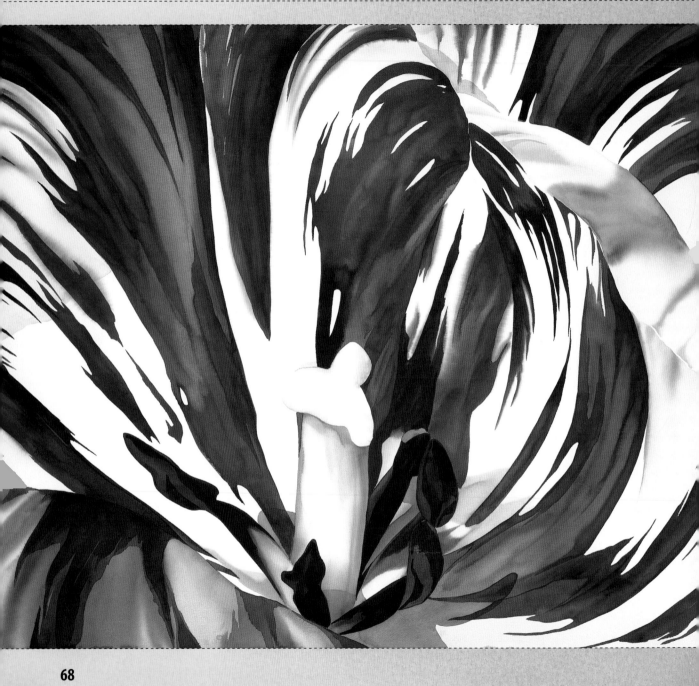

powerful paintings, step by step

5

When painting, you are able to create whatever you wish. Think of ways to present a traditional subject in a new way; it isn't necessary to paint every detail. The goal is to make a painting that carries impact and leaves a lasting impression. Much can be said by only a suggestion. Simplify your subject and invite the viewer into your world. Lead the eye through the images of shape, values, shadows and color; have some fun by spattering color and using negative space. There are so many options available. All these techniques and small touches enhance the image and add to the story of your painting.

Transform simple subjects into powerful paintings
Minimizing detail and focusing on shapes and color can change a seemingly simple flower into a strikingly bold image. Brushstroke direction and color can also help.

THE WAVE
WATERCOLOR ON 300-LB. (640GSM)
COLD PRESS
40" × 60" (102CM × 152CM)

painting in shapes

By working in small, individual, abstracted portions and breaking a subject into parts, you start to release the idea of what you think the image should look like and start to see only shapes. This forces you to develop more of a feeling for space and to open your intuitive, creative self, releasing the linear mind of reason and losing the constant need to know what you are looking at.

These next simple exercises using limited color will help you internalize techniques for creating the illusion of a folding petal or lifting an object away from the surface, all by the simple placement of a stroke of color.

1 Prepare the paper

Make four rectangles on your watercolor paper. In each rectangle, sketch half an oval that extends over the sides. You'll erase the pencil lines outside the rectangle later.

MATERIALS

Paper | ¼ sheet 140-lb. (300gsm) cold press

Brushes | Large natural-hair brush such as a 1-inch (25mm) mop, no. 30 round or 2½-inch (6cm) bamboo hake • No. 8 sable/synthetic blend round

Pigments | Burnt Umber • French Ultramarine

Other | Graphite pencil • Ruler

2 Apply the first stroke of color
Working one square at a time, use a large natural-hair brush to flood the inside of the abstracted petal with clean water. Prepare a mixture of Burnt Umber and French Ultramarine on your palette to create a nice gray. As the glisten of the water starts to leave the surface, with a light touch, apply a stroke of color using a no. 8 sable/synthetic blend round just under the top pencil line, varying the width—thinner at both ends and wider in the center. Allow it to dry.

3 Fill in the background
Add this same gray mixture to the surrounding area of the background using a no. 8 sable/synthetic blend round. This contrast will bring out the lighter areas and enhance the shape.

3 Add the background
Using a no. 8 sable/synthetic blend round, add a still darker background. This focuses the eye on the lighter highlights, giving the impression of shape.

2 Apply two strokes of color
Using a no. 8 sable/synthetic blend round, apply one stroke along the top and one on the bottom. This helps to add to the illusion of an image rolling over and folding under.

71

shadows

Shadows are one of the most important elements in a painting. On a cloudy day when the sun does not cast much high, contrasting light, objects have more of an even tone without much definition. Painting an image in this type of light can result in a flat and uninteresting piece. To avoid this, you can add your own light source: Decide where the light source will be and add shadows on the opposite side.

The more high, contrasting light there is, the harder and more defined the shadow edges will appear. If light is able to penetrate or filter through an object, the values of the cast shadows will be lighter, while denser objects will cast darker shadows.

Show filtered light with soft shadows
In this progression of three abstracted shapes in filtered light, there are no defined shadows. The only way to lift the image away from the background is to darken the values in the corners. Using a darker color in the background helps to contrast the highlights and add depth.

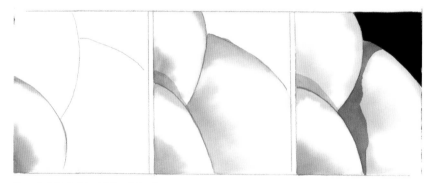

Show bright light with hard shadows
Give the impression of bright daylight using crisp shadow lines and varying degrees of values. This can lead the eye from one level into the next.

using soft and hard shadows

To achieve the best results, combine both soft and hard shadows. In this rose detail, you'll see that using soft, crisp lines and different degrees of values is extremely important in creating shape and dimension.

MATERIALS

Paper | ¼ sheet 140-lb. (300gsm) cold press

Brushes | Large natural-hair brush such as a 1-inch (25mm) mop, no. 30 round or 2½-inch (6cm) bamboo hake • Nos. 8 and 20 sable/synthetic blend rounds

Pigments | Burnt Umber • French Ultramarine • Indigo

Other | Graphite pencil

1 Begin with a sketch and simple strokes
In your palette, create a gray mixture of Burnt Umber and French Ultramarine. Working one petal at a time, fill the petal with water, then apply simple strokes of the mixture using a no. 8 sable/synthetic blend round.

2 Work the values
Using the same gray mixture (add a little Indigo if needed), add darker values for shadows using a no. 8 sable/synthetic blend round to give the illusion of dimension. If more blending is needed, use your large natural-hair brush.

3 Add the background
Using your sable/synthetic blend rounds (no. 20 for the large areas and no. 8 for smaller areas), add a dark, contrasting background. Apply the darkest value of your gray mixture (or straight Indigo) to dry paper to help bring the lighter colors forward while recessing the darker ones into the background.

73

adding shapely details

Using the same idea from the previous exercises, learn how applying a simple stroke of color can give your images more shape and add life to your paintings.

MATERIALS

Paper | ¼ sheet 140-lb. (300gsm) cold press

Brushes | Large natural-hair brush such as a no. 30 round, 1-inch (25mm) mop or 2½-inch (6cm) bamboo hake • Nos. 8 and 14 sable/synthetic blend rounds

Pigments | Indigo • New Gamboge • Permanent Alizarin Crimson • Permanent Sap Green

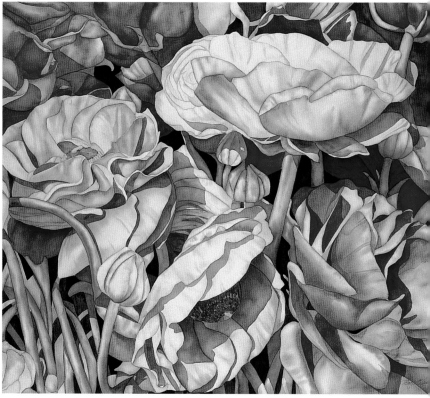

Shaping detail
Using different variations of green along with other colors enhances the shapes in your painting and helps to change the mood or feeling and add interest. There is no need to add every stem; you want only to give the impression, allowing the viewer to use his or her imagination.

THE DANCE
40" × 43" (102CM × 109CM)
WATERCOLOR ON 300-LB. (640GSM) COLD PRESS

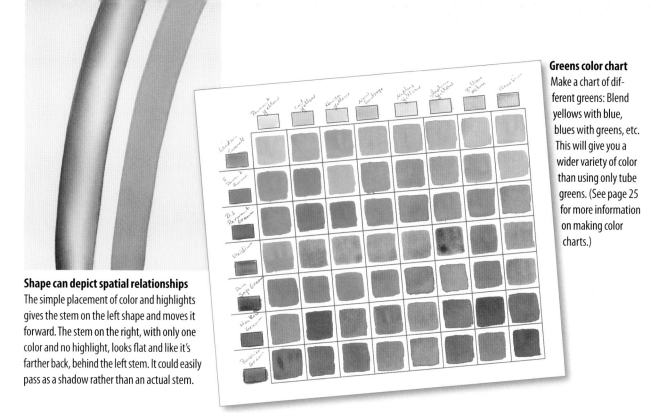

Shape can depict spatial relationships
The simple placement of color and highlights gives the stem on the left shape and moves it forward. The stem on the right, with only one color and no highlight, looks flat and like it's farther back, behind the left stem. It could easily pass as a shadow rather than an actual stem.

Greens color chart
Make a chart of different greens: Blend yellows with blue, blues with greens, etc. This will give you a wider variety of color than using only tube greens. (See page 25 for more information on making color charts.)

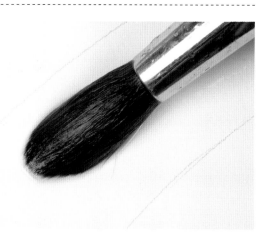

1 Add water
Using a large natural-hair brush, fill the inside of the stem with enough clean water so color is able to flow freely when it's applied.

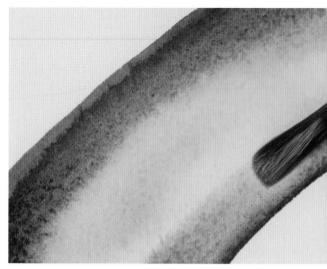

3 Begin shaping
While the surface is still damp, add a small stroke of Permanent Alizarin Crimson to one side and New Gamboge to the other. The lighter center helps give shape and accent the colors while allowing them to gently blend without overpowering each other. To prevent the colors from mixing and turning muddy, use a no. 8 sable/synthetic blend round. Keep your brushstrokes to a minimum.

2 Begin adding color
Using a no. 8 sable/synthetic blend round, apply Permanent Sap Green or another green mixture to both sides of the stem. To prevent both sides from looking the same, make one side wider than the other, leaving enough white area in the middle so the color can naturally transition from the edge into the center. This gradual transition of color and value will give the impression of the stem being round; if there is too much of the same color throughout the stem, it can easily appear flat.

4 Add depth and build color

To add depth, add another layer of color when the stem is completely dry. Add a small amount of Indigo to your green palette mixture to deepen the green. Then, using a no. 14 sable/synthetic blend round, apply the color directly to dry paper. (Applying the color to dry paper helps to keep the integrity of the hue without washing out too much.) With your large natural-hair brush, soften the inside edges, leaving it lighter on the inside and darker on the outside to give it as much form as possible.

5 Blend

If too much color has bled back into the center, lift out the extra water or color with a clean, damp (but not wet) large brush. Using a larger brush will help prevent the appearance of too many brushstroke marks and eliminate potential backwashing or unwanted blossoming.

6 Create an illusion

You can see how the soft, blended color and transitions create optimum shape with the lighter highlighted center. The darker edges give the appearance of the stem being rounded and tubular rather than flat and boring.

using complementary colors

A nice way to tie a composition together while adding life to your painting is to use complementary colors. However, care is needed. If overmixed, complements can easily turn into neutral gray. To prevent this, make sure you leave enough space between the two colors so each one is easily visible and gently transitions into the other. This technique is similar to the one you used on the stem, placing the darker green color on the outside and the lighter value on the inside. This gives you room to add the complement.

MATERIALS

Paper | ¼ sheet 140-lb. (300gsm) cold press

Brushes | Large natural-hair brush such as a no. 30 round, 1-inch (25mm) mop or 2½-inch (6cm) bamboo hake • ¼-inch (6mm) nylon flat • Nos. 8 and 20 sable/synthetic blend rounds • No. 20 synthetic round

Pigments | New Gamboge • Permanent Alizarin Crimson • Permanent Sap Green

Other | Graphite pencil

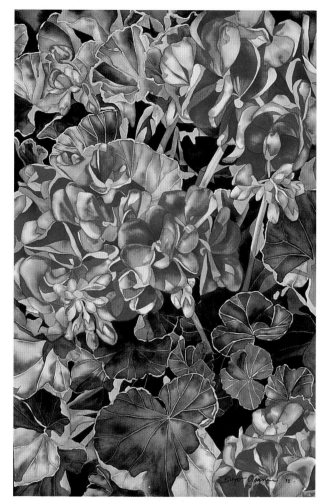

Complements can pull together a composition
The red flowers are the main focus in this composition; the leaves add to its complexity. Incorporating some of the complementary red into the leaves helps pull the painting together.

YESTERDAY'S MEMORY
40" × 25" (102CM × 64CM)
WATERCOLOR ON 140-LB. (300GSM) COLD PRESS

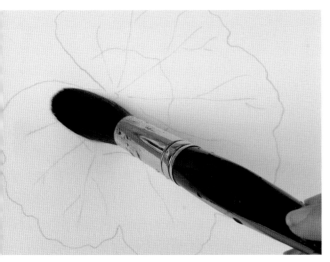

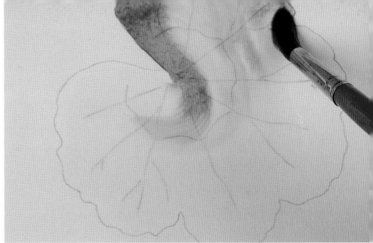

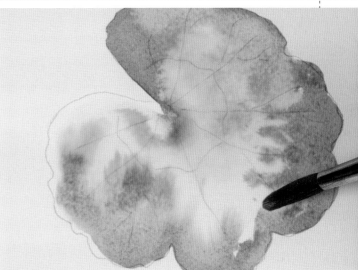

1 Add water

After you have sketched your leaf, fill the inside area using clean water and your large natural-hair brush, going almost up to the pencil line but not quite touching it. If you go all the way to the line, you risk going too far over it; when you add color, the edges won't be as crisp. Apply enough water so the color is able to flow freely.

2 Lay down the color

Using a no. 8 sable/synthetic blend round, apply a mixture of New Gamboge and Permanent Sap Green or your favorite green mixture along the edge of the pencil line, leaving the center with as little color as possible and allowing the green to run back gently into the clean water, creating a soft blend.

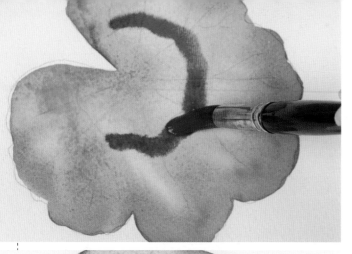

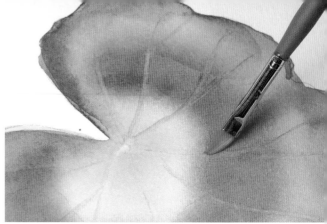

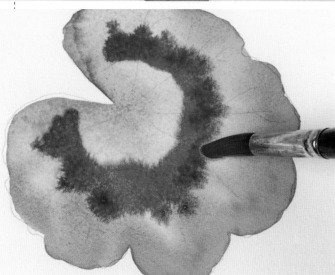

4 Add the illusion of veins
Use a ¼-inch (6mm) nylon flat for this step. The nylon bristles of the synthetic brush (usually used for acrylic paints) are much stiffer than those used for watercolor, allowing you an easy, inexpensive way to create natural-looking lines.

Starting with the largest and most visible veins, hold the brush at an angle, then lift out or scrub with the side of the tip of the brush.

VIDEO / Veining in a flower

3 Adding a complementary color
As the surface becomes matte in appearance, use a no. 20 synthetic round to apply the complementary red. Here, Permanent Alizarin Crimson works quite nicely. A synthetic brush gives you more control without applying too much water or color. Keep your strokes to a minimum and apply them in only one application to the middle of the leaf, following the shape of the edge. Because the center is a lighter green than the outside edge, the Permanent Alizarin Crimson is able to hold its own color without overmixing and turning gray.

ACRYLIC BRUSH = NYLON FLAT

In the DVD that accompanies this book, I'll occasionally direct you to use an acrylic brush. While any stiff flat meant for use with acrylic paints will do, a simple ¼-inch (6mm) to ½-inch (12mm) nylon flat is what I most often use.

5 Give the veins shape

Once you've lifted out the color and allowed the leaf to dry once more, place a light stroke of color along one side of each vein with a no. 8 sable/synthetic blend round to add depth to the veins. Smooth out unwanted hard lines with a clean no. 20 sable/synthetic blend round. Lift and tilt the paper to blend color as needed. Allow it to dry.

DETAILS

Simplify and try not to worry about every detail. Give only a suggestion, then let the imagination to fill in the rest.

6 Reevaluate

Once dry, reevaluate the color. If it appears light or washed out, apply more layers. Repeat the process in steps 4 and 5. The more layers you add, the more dramatic the veining will appear.

using masking fluid

Masking fluid can be quite helpful, giving you great contrast and clean lines whether you apply it directly to the white of the paper or to a dried wash of color. But if not applied carefully, it can take on the appearance of unwanted harsh lines when removed.

Before applying masking liquid, make sure the surface is dry. Then use either an incredible nib, bamboo pen or an old, disposable brush to apply the masking fluid. Allow the masking to dry before applying a wash of color.

MATERIALS

Paper | ¼ sheet 140-lb. (300gsm) cold press

Brushes | Large natural-hair brush such as a 1-inch (25mm) mop, no. 30 round or 2½-inch (6cm) bamboo hake • ¼-inch (6mm) nylon flat • Nos. 8, 14 and 20 sable/synthetic blend rounds

Pigments | French Ultramarine • Indian Yellow • Sap Green

Other | Graphite pencil • Masking fluid • Old, small disposable brush, incredible nib or bamboo drawing pen (for masking fluid) • Rubber eraser

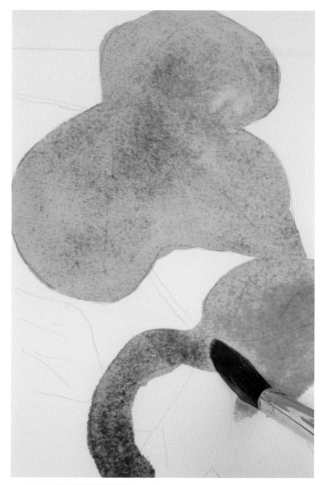

1 Apply the first wash
Draw some simple leaves and apply a flat wash of Sap Green mixed with French Ultramarine, or Indian Yellow mixed with French Ultramarine, using your no. 20 sable/synthetic blend round. This is an easy way to prevent having to add color to the veins after the masking has been removed.

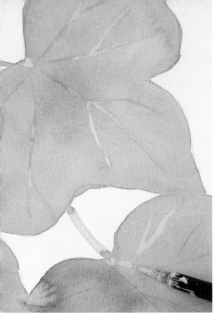

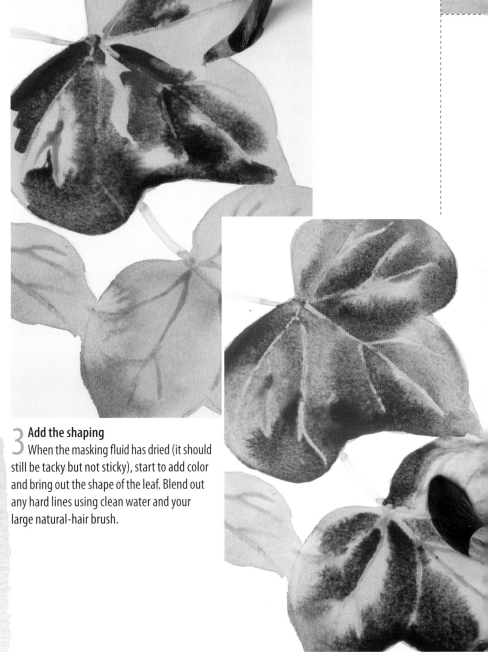

2 Apply the masking fluid

After the wash has completely dried, apply the masking fluid using an old, small disposable brush, incredible nib or bamboo drawing pen. Make sure the wash is completely dry before beginning, or the masking fluid won't make clean lines.

IF YOU USE A BRUSH FOR MASKING

Don't use a good brush, because you can easily ruin it. A masking brush should be specifically designated for masking. To keep the fibers' integrity longer, first dip it in a solution of water and mild detergent, then apply the masking fluid or drawing gum. Wash the brush when you're finished.

3 Add the shaping

When the masking fluid has dried (it should still be tacky but not sticky), start to add color and bring out the shape of the leaf. Blend out any hard lines using clean water and your large natural-hair brush.

83

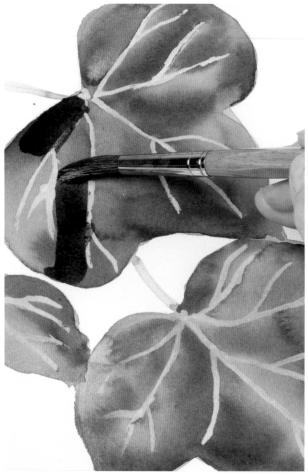

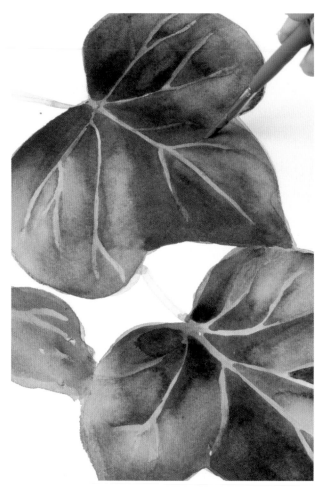

4 Remove the masking fluid

When you're satisfied with the color, and after the painting is completely dry, remove the masking by rubbing it off with your fingers or a rubber eraser. To clean up or straighten any harsh lines, use a no. 8 or no. 14 sable/synthetic blend round to reapply color or soften the edges.

5 Reevaluate

When you're finished, reevaluate. If more veins or details are needed, use a ¼-inch (6mm) nylon flat to refine the veins.

spattering for texture

Seasons change, and so do the colors, from greens in the spring to golds and reds in the fall. All the seasons can give you an opportunity to add texture, play, experiment and simply have fun. A maple leaf, for instance, changes dramatically, from strong new growth in the spring to beautiful and fragile in the fall.

In this demonstration you'll add soft, fragile-looking texture using smaller brushes and a fun spattering technique.

MATERIALS

Paper | ¼ sheet 140-lb. (300gsm) cold press

Brushes | Large natural-hair brush such as a 1-inch (25mm) mop, no. 30 round or 2½-inch (6cm) bamboo hake • Nos. 8 and 14 sable/synthetic blend rounds • No. 3 synthetic round

Pigments | Permanent Alizarin Crimson • Quinacridone Gold

Other | Graphite pencil

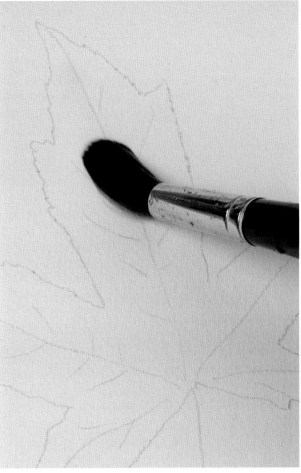

1 Draw, then add water
Complete a sketch of a leaf, not worrying about too many details. Using a large natural-hair brush, fill the inside of the leaf with clean water so no one area dries quicker than the other. (Don't panic if you happen to get dry spaces; you can use them to give the impression of fragility later on. The color will travel only in water, leaving the appearance of small holes in the leaf.)

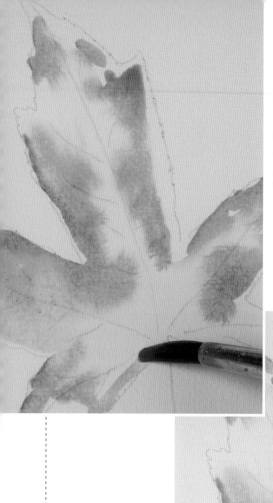

2 Begin adding random color

Apply different values of Quinacridone Gold randomly around the edges using a no. 14 sable/synthetic blend round so the color may run freely back into the clean water of the leaf. Incorporate a little Permanent Alizarin Crimson into the Quinacridone Gold for interest.

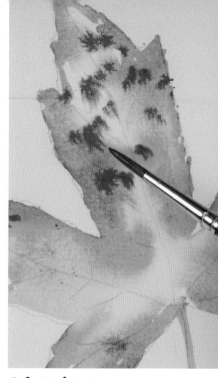

3 Spatter for texture

As the surface is drying, spatter a little Permanent Alizarin Crimson or even clean water inside the leaf, using a no. 8 sable/synthetic blend round. The size of the brush determines the size of many of the spatter marks and droplets of color.

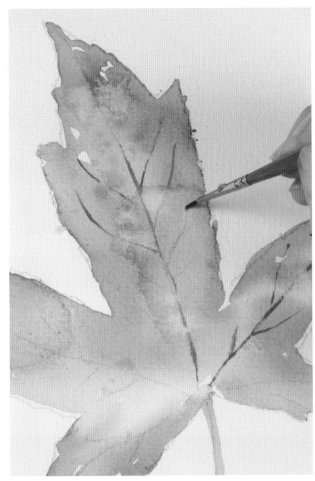

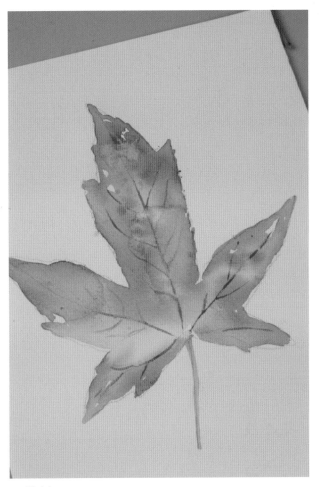

4 Add the veins

While the surface is still slightly damp, paint in the veins using a no. 3 synthetic round. The small brush will give you more control over the width of the vein; the synthetic fibers hold less water, so the color is less likely to dissipate. The slightly damp surface makes the veins appear softer and not as harsh. If there's too much water on the leaf or if the color is still too damp, the veins may be reapplied.

5 Finish

At a distance, you can see how the areas left dry helped give the impression of a weathered leaf. The veins are visible but not distracting and the differences in the color help make the leaf more interesting.

making rough edges and lifting details

Smaller brushes are useful for working details such as uneven edges and small highlighted areas. Let's practice this on these rose leaves. Rose leaves have little points similar to the thorns on the main stems.

MATERIALS

Paper | ¼ sheet 140-lb. (300gsm) cold press

Brushes | ¼-inch (6mm) nylon flat • Nos. 8 and 14 sable /synthetic blend rounds • No. 3 synthetic round

Pigments | French Ultramarine • Indian Yellow • Permanent Alizarin Crimson

Other | Graphite pencil

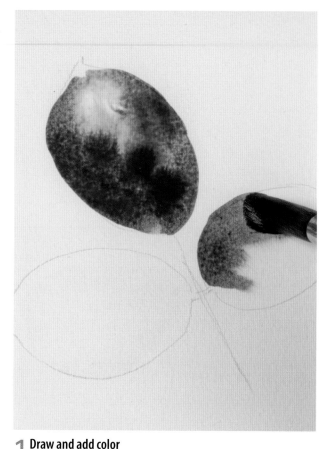

1 Draw and add color
Apply water to the inside of the leaf. Mix a green combination of French Ultramarine and Indian Yellow in your palette. Then, using a no. 8 or 14 sable/synthetic blend round (depending on the size of the leaf), apply it to the inside of the leaf along the edges.

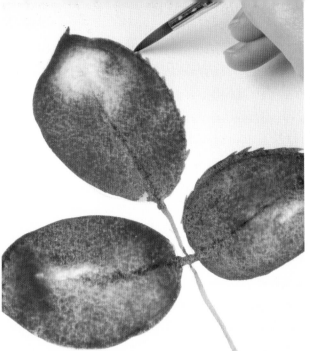

2 Pull out some edges
The ridged edges around the leaves are similar to the thorns on a stem. While the color is still damp, pull out some of the edges with the tip of a no. 3 synthetic round.

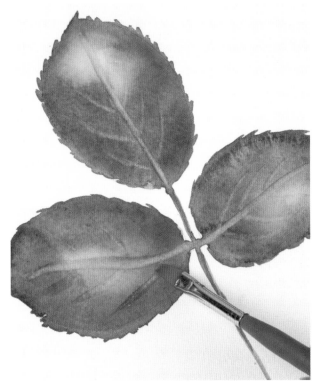

3 Lift out the details
Once dry, use a ¼-inch (6mm) nylon flat to lift the details and to give the impression of veins. Using the nylon brush rather than masking fluid helps give the leaf a more natural appearance. Adding a complement, such as Permanent Alizarin Crimson, along the inside edge can make the leaf more colorful and interesting.

pulling it all together

Using a combination of the techniques covered so far, you can see how spattering, along with the use of shadows and value variations, work together to create powerful paintings. In the pages that follow, you'll use the natural movement of watercolor to create complete compositions.

Combine techniques

In this unusually purple succulent painting, I spattered clean water and color onto the petal as it was drying to give the impression of the salt technique without the mess. The composition faces away from the light into the shadows; notice the wide range of values that help create the illusion of depth.

PURPLE SUCCULENT
22" × 30" (56CM × 76CM)
WATERCOLOR ON 300-LB. (640GSM) COLD PRESS

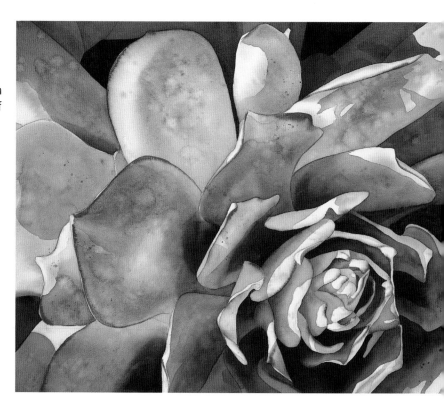

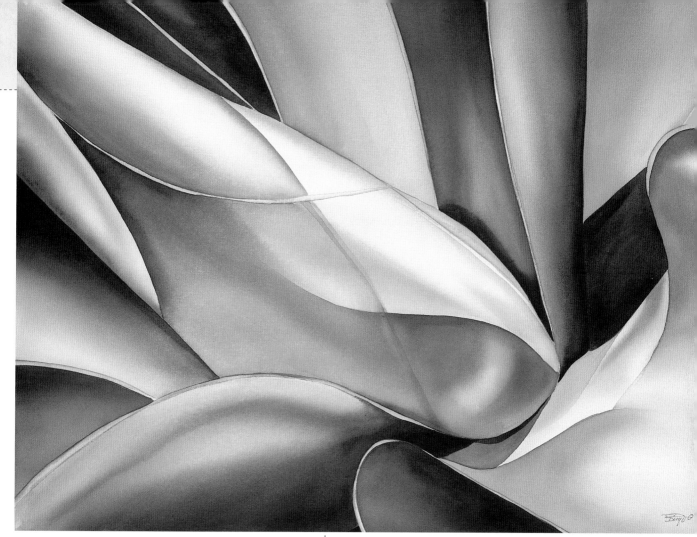

Color and value contrast work with stroke variation

Here is a perfect example of high contrasting light and shadow. The lighter values come forward as the gradual progression of the shadows help lead the eye into the background. The touch of Permanent Alizarin Crimson on the edges softly blend into the greens, complementing both the colors. Notice the change in color and direction of the stroke in each petal; this is what gives the painting its direction and shape.

SANTA BARBARA
40" × 60" (102CM × 152CM)
WATERCOLOR ON 1114-LB. (2340GSM) COLD PRESS

glazing for translucency

When light passes through a flower and one petal overlaps another, some areas appear darker. (How much darker depends on the density of the petal and how much light is able to shine through.) You can easily replicate this effect by glazing one transparent color over the other.

MATERIALS

Paper | ¼ sheet 140-lb. (300gsm) cold press

Brushes | No. 30 natural-hair round, 3-inch (8cm) mop or 2½-inch (6cm) bamboo hake • No. 20 sable/synthetic blend round

Pigments | Indian Yellow • Permanent Alizarin Crimson

Other | Graphite pencil

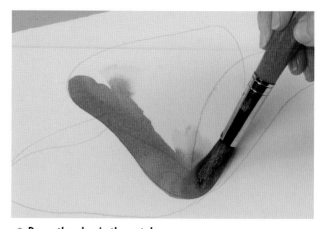

1 Draw, then begin the petals
Lightly sketch the shapes that will become your petals. Mix together Indian Yellow and Permanent Alizarin Crimson. Use the no. 20 sable/synthetic blend round to fill one petal with water and apply color to it, painting over the pencil lines of the other petals. Let it dry.

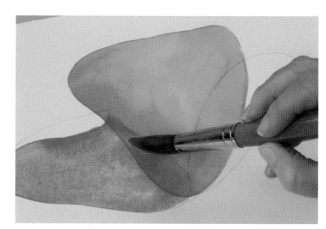

2 Repeat the process
Using the same brush, repeat the water and color application on the second petal, overlapping and glazing over the edge of the first.

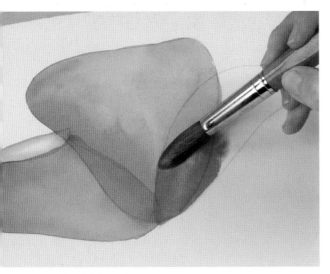

3 Paint the third petal
Repeat this on the third petal. As color glazes over the first petal, it creates a darker value, leaving the impression of transparency.

4 Finish
Using the most transparent color when glazing creates more of a delicate appearance and can leave the illusion of one petal overlapping another.

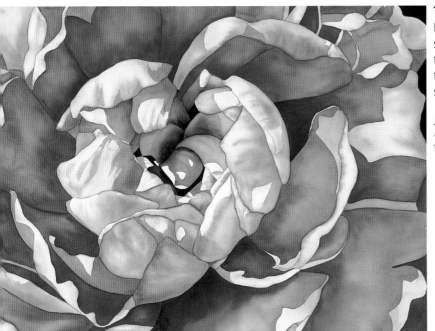

Translucency in action
Here, the translucent effect was used more in the shadows, leaving the impression of light passing through one petal onto another. As you travel into the center, the variation in values gives the impression of some petals moving forward as others recede.

JOURNEY
40" × 60" (102CM × 152CM)
WATERCOLOR ON 300-LB. (640GSM) COLD PRESS

reserve whites for highlights

Reserving whites and surrounding them with gentle transitions of color will help you create depth. When applying color to a petal, for example, leave enough white area in the center for highlights. Use ample amounts of water, too, to give you more time to work on an area and allow your pigments to blend easily and leave the impression of movement and shape.

MATERIALS

Paper | ½ sheet 300-lb. (640gsm) cold press

Brushes | No. 30 natural-hair round • Nos. 14 and 20 sable/synthetic blend rounds • 2½-inch (6cm) bamboo hake, mop or wash brush

Pigments | French Ultramarine (or Cobalt Blue) • Indigo • Permanent Alizarin Crimson • Permanent Sap Green • Quinacridone Magenta • Winsor Blue (or Carbazole Violet)

Other | Graphite pencil

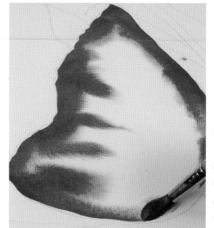

1 Begin
Lightly sketch three petals on your paper to make a poppy shape. Apply clean water to one petal. Create a mixture of Permanent Alizarin Crimson and Quinacridone Magenta, then randomly apply color along the edges of the petal using a no. 20 sable/synthetic blend round.

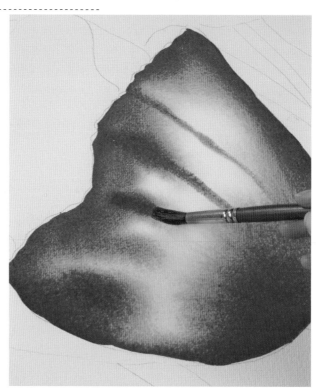

2 Continue applying color
As the color is starting to dry, use a no. 14 sable/synthetic blend round to reapply color in sweeping strokes from the outside edge to the center. This will help to give the petal shape. Then, lift and move the paper to blend the color. Allow to completely dry.

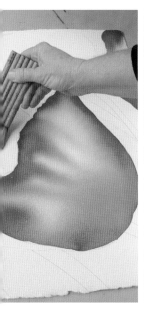
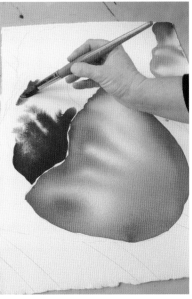
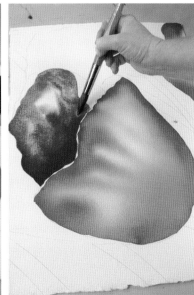

3 Continue, painting one petal at a time

Repeat steps 1 and 2, keeping the darkest value closest to the inside of the center of the flower. As one petal dries, move on to the next.

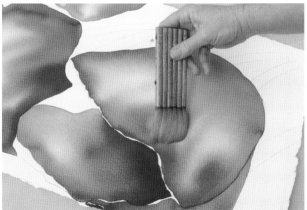

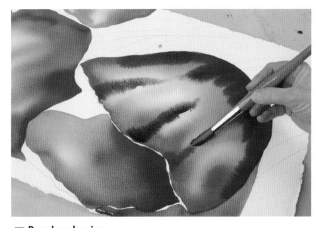

4 Layer color

Layering and glazing color upon color helps create rich hues. After an area dries, reapply water using a soft wash brush, then apply the additional layer. To define the separations between petals, randomly leave small white lines along the edges of the petals. These will be the lip of the petals, which you will fill in later.

5 Develop shaping

As the petal is drying, add shaping using the same mixture as before with the addition with Carbazole Violet or Winsor Blue. Apply bold strokes of the mixture to damp paper, allowing the color to blend. Lift and tilt the paper to let the pigments blend naturally. If color isn't moving, there isn't enough water.

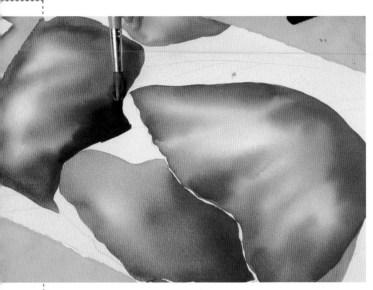

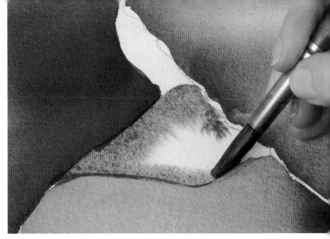

7 Paint smaller areas with smaller brushes

Treat the smaller areas in the painting the same as the larger ones; just use smaller brushes. Wet the smaller areas using a no. 20 sable/synthetic blend round, and apply the pigments (the same pigments you used with the larger portions) using a no. 14 sable/synthetic blend round. The main difference in treating smaller areas is that you'll want to keep the pigment more along the edges, leaving lighter, highlighted areas in the centers to give the appearance of shape and fold.

6 Blend color

As you work your way around the flower, darken the values inside and under each petal. The surface of the paper and the amount of water used affects how well the color blends.

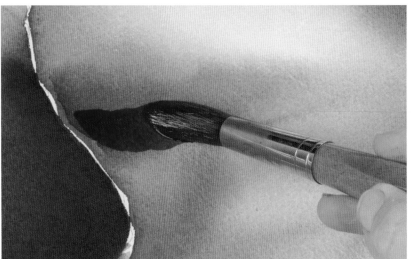

8 Begin a petal fold

Using the previous layer of pigment as a guide, use a loaded no. 20 sable/synthetic blend round to apply a brushstroke to dry paper to suggest where folds or shapes may be.

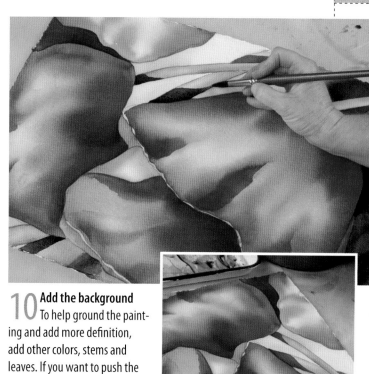

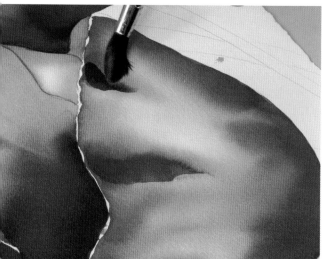

10 Add the background
To help ground the painting and add more definition, add other colors, stems and leaves. If you want to push the background back, use the wet-into-wet technique and darker values—with a combination of Indigo and Permanent Sap Green on the bottom—to give the impression of dense vegetation. Use French Ultramarine or Cobalt Blue for the sky. To keep the sky from looking too flat, soften the edges with clean water.

9 Blend one side of the fold
Before the pigment completely dries, use a clean, damp no. 20 sable/synthetic blend round to soften one side of the brushstroke edge.

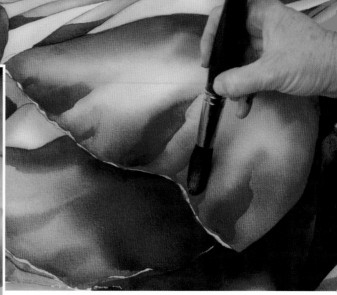

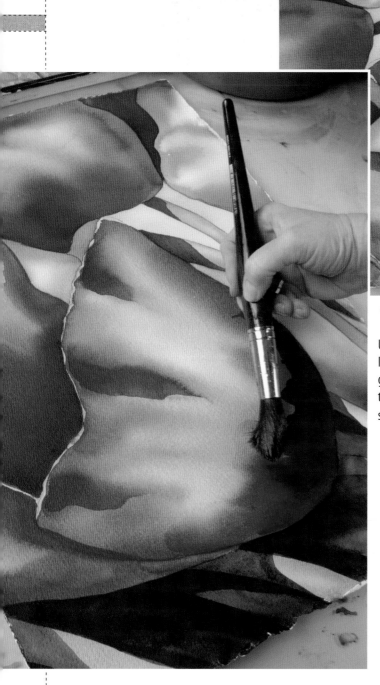

11 Add the final details

Fill all the shapes and white areas with pigment as needed. Use small brushes for smaller areas, large brushes for larger areas. If you want to deepen a value, use the previous layer's color as your guide. Apply pigment directly to dry paper, then soften the edges into the surrounding areas using a no. 30 natural-hair round or a no. 20 sable/synthetic blend round.

Reserving the highlights ▶

Determine the appearance of your subject and where the light hits it from the beginning. Then allow your brushstrokes, water amounts and flow to add life and movement to the composition.

POPPIES IN THE WIND
40" × 30" (102CM × 76CM)
WATERCOLOR ON 300-LB. (640GSM) COLD PRESS

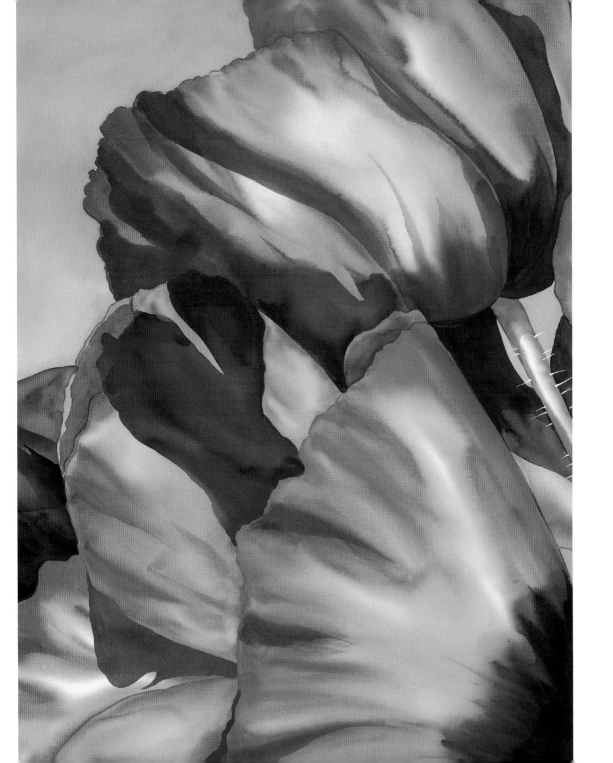

building color

Here, instead of mixing color on the palette, you'll allow two pigments to blend directly on the paper (see page 34). Both pigments can appear separate in intensity, but with a nice transitional, blend into a third color. The white areas you leave (see page 94), the amount of water you use, and the different values will give the washes a luminous appearance.

MATERIALS

Paper | ½ sheet 300-lb. (640gsm) cold press

Brushes | No. 30 natural-hair round • Nos. 14 and 20 sable/synthetic blend rounds • Nos. 3 and 8 synthetic rounds • 2- to 3-inch (5 to 8cm) mop, bamboo hake or wash brush

Pigments | Carbazole Violet • French Ultramarine • Indian Yellow • Indigo • Permanent Alizarin Crimson • Permanent Sap Green • Quinacridone Magenta • Winsor Red

Other | Graphite pencil

1 Draw, then begin the petals one by one
Lightly sketch the flower on your paper. Then work around the painting one petal at a time (see step 1 close-up). This allows you to have more control over the color and blended transitions.

WHEN TO USE A HAKE

Use a bamboo hake brush when you're more concerned about laying down a large amount of water than laying down an even layer of water.

step 1 close-up | petals one by one

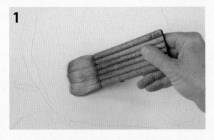

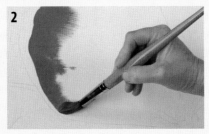

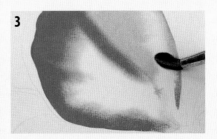

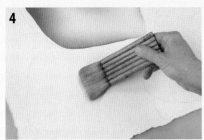

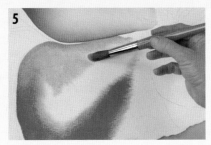

1 Begin with water
Apply clean water to only one petal using a bamboo hake or large wash brush.

2 Lay down color
While the surface still glistens, use your no. 20 sable/synthetic blend round to apply a mixture of Winsor Red, Quinacridone Magenta and Permanent Alizarin Crimson along the edges and down the middle (one quick stroke).

3 Transition and blend colors
Immediately after you've applied the red, add Indian Yellow along the other side. Lift and tilt the paper and allow colors to transition and blend. The amount of water will determine how well the color mixes.

4 Allow to dry, then move on
Move on to the next petal or work areas that aren't next to the wet petal. Allowing the paper to completely dry prevents color from bleeding from one petal to the next.

5 Repeat the color application
Repeat the color application from steps 1 to 4, then allow to dry again. Be sure to leave enough white space between colors to allow the two to gently blend together and give the illusion of highlights.

6 Lift and tilt to blend
Lifting and tilting the paper side-to-side will control the flow and direction of color. This back-and-forth motion moves the water and color, creating smoother blends. Heavier 300-lb. (640gsm) paper works best for this technique and helps to avoid any buckling.

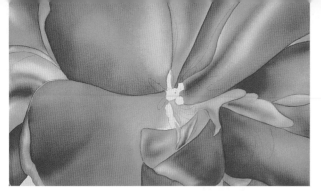

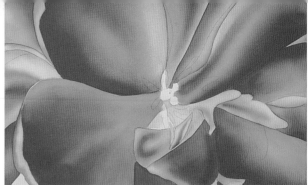

2 Examine the values

Once each petal is filled with color, allow the painting to completely dry so you can see the overall values in the painting. It should look similar to this. Notice how much lighter the color has dried. The painting will have the same value overall.

3 Add another layer to build intensity

Be selective where you reapply color. Using the same pigments and brushes you used for step 1, begin adding more color. Lighter highlights do not need to be reworked; add additional layers in areas where more color or darker values are needed. Work toward building contrast so lighter areas move forward.

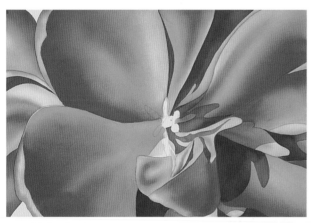

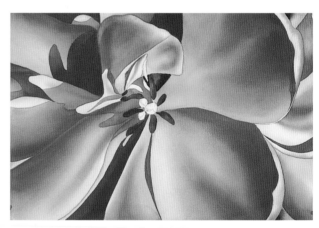

4 Add the shadows

For the shadows, use the same colors you used for the petals with the addition of small amounts of Carbazole Violet, Winsor Red or Indigo. Use the no. 14 sable/synthetic blend round for larger areas, and the no. 8 synthetic round for smaller ones. Avoid going too dark too fast; you can't go back. If you try to lift the shadow color out, it will leave a dark line around the shadow, which creates an overworked appearance.

5 Add the details

When a painting has a strong dominant color, the details and different hues can be enough to break it up. Treat details within the petals first. Use a no. 8 synthetic round and a mixture of Indian Yellow, Permanent Alizarin Crimson and Carbazole Violet to add in details and highlights. Let the color flow back into the center. Use Indian Yellow mixed with Indigo (or just Permanent Sap Green) for the very center of the flower. For the tops of the stamens and the background, use Indigo, or your choice of complementary greens, and your smallest brushes.

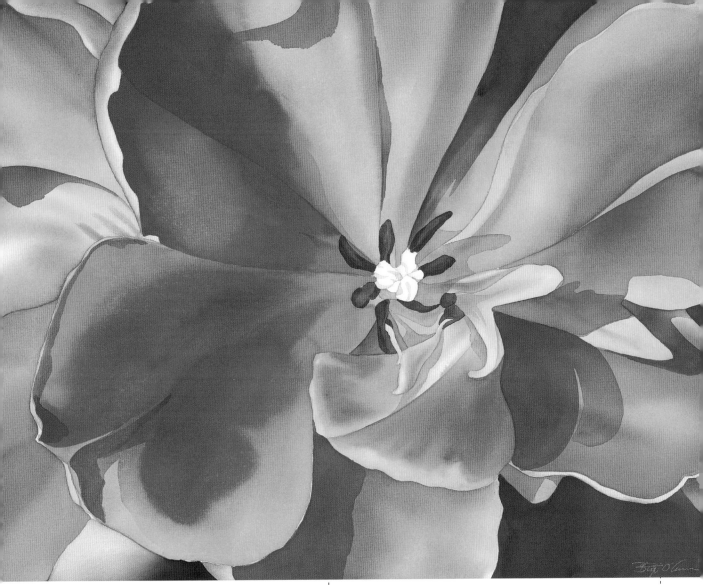

Experiment

Change the composition or colors as much or as little as you wish. This way, you start to find out what you will like within your own paintings. Here, I brought in more Indian Yellow, kept the values lighter in the shadows, added a tiny bit of Permanent Sap Green into two of the corners and mixed French Ultramarine with Indigo for the background.

RED TULIP
22" × 30" (56CM × 76CM)
WATERCOLOR ON 300-LB. (640GSM) COLD PRESS

controlling complementary colors

Complementary colors work well to create beautiful neutral grays for shadows, and, when placed side by side, complements make one another more vibrant. The big challenge in this composition of a pansy is learning to control color on both your palette and side by side on the paper to avoid making mud.

MATERIALS

Paper | ¼ sheet 300-lb. (640gsm) cold press

Brushes | No. 30 natural-hair round or any size mop or wash brush • Nos. 14 and 20 sable/synthetic blend rounds • No. 8 synthetic round

Pigments | Carbazole Violet • French Ultramarine • Hansa Yellow • Indian Yellow • Naples Yellow • Permanent Sap Green • Quinacridone Magenta

Other | Graphite pencil

1 Begin

Lightly sketch the petals of a pansy on your paper. Mix Naples Yellow and Indian Yellow on your palette. Starting with the lightest petals, use a no. 30 natural-hair round to fill one petal almost to the pencil line with clean water. Then, using a no. 14 sable/synthetic blend round, apply the color mixture only to the inside of the edge line, allowing the yellow to gradually bleed back into the center. This way, it will stay separate from the purple. The key here is to leave enough space for the two pigments to be side by side with gradual blending along the edges rather than mixing and turning into mud.

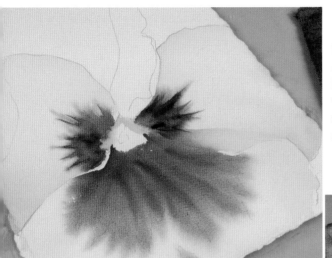

2 Apply purple to the center

Create a mixture of Carbazole Violet, French Ultramarine and Quinacridone Magenta on your palette. As the surface becomes more matte, apply the purple mix with a no. 14 sable/synthetic blend round, starting in the center using sweeping strokes out toward the outside edge.

SMALL WONDERS, BOLD COMPOSITION

With small flowers, it is not always easy to recognize a good composition. The immediate response is usually to clump them together and make a bouquet. Focus on shape, shadow and color to help you transform these small wonders into bold compositions.

3 Complete the first layer and allow to dry

After you've added color to all the petals, allow the painting to dry. As the purple starts to dry, it begins to lighten. More layers are needed to intensify the color. This can usually be achieved in three layers.

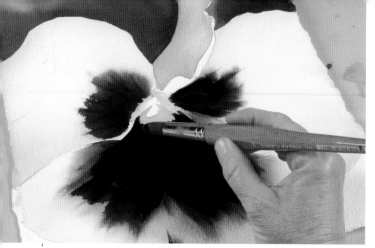

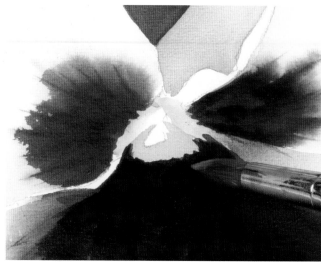

4 Intensify the color

To help soften the brushstrokes and intensify the color, use the same mixture as in step 2, and a no. 20 sable/synthetic blend round, to continue to darken the inside of the flower. The contrasting colors (yellow and purple) will give the painting vibrancy and clarity. Continue to work the overall flower by layering. The larger brush helps eliminate brushstrokes, lay down more pigment, and cover the larger areas more quickly.

Leave white areas to separate the petals
Leaving a few white areas along the lip of the petal helps separate them; you will fill these in later with a lighter value.

5 Begin the shadows

After all the color has been added and the petals are dry, start the shadows. Create a neutral gray by combining the mixtures of the purple and yellow. Place shadows in areas that face away from the light source or in areas where one petal overlaps another. Work the shadows one at a time. For larger shadows, apply the water first (only to the intended shadow area) using a no. 20 sable/synthetic blend round. Then, apply the color mixture using a smaller brush that you can control in tighter areas. Allow the water to carry the color and naturally transition the values.

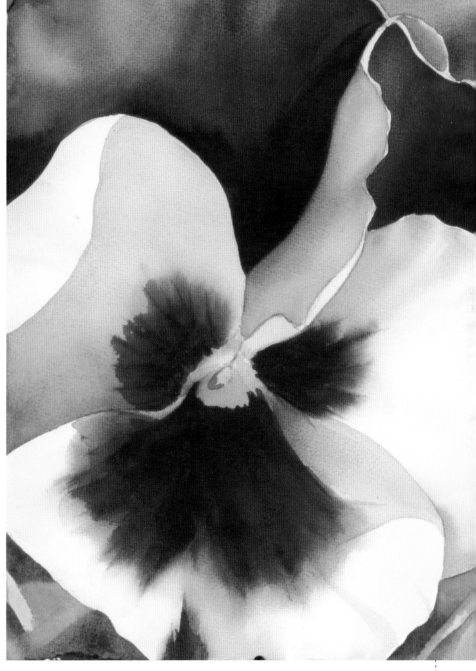

6 Add the background
Once you're done with the color and shadow, add the background using the no. 14 sable/synthetic blend round or the no. 8 synthetic round and Permanent Sap Green mixed with Hansa Yellow or French Ultramarine.

Finished painting
Using the yellow mixture along the edges effectively gives the impression of a soft color without overpowering the petal. The addition of greens in the background helps stimulate both the yellows and the violets, bringing together the entire painting.

SPRING PANSY
15" × 11" (38CM × 28CM)
WATERCOLOR ON 300-LB. (640GSM) COLD PRESS

working with whites

Painting white subjects can be a challenge. Here, you'll learn to meet that challenge using mostly water, the color from your wash bucket, brushstrokes and shadow. To make the painting more dramatic and push the image forward, you'll build the darker colors in the negative space in the background.

MATERIALS

Paper | ½ sheet 300-lb. (640gsm) cold press

Brushes | No. 30 natural-hair round • No. 20 sable/synthetic blend round • No. 8 synthetic round

Pigments | Burnt Sienna • Burnt Umber • French Ultramarine • Indigo • Naples Yellow • Quinacridone Magenta • Permanent Sap Green

Other | Graphite pencil

1 Draw, then begin petals
Lightly sketch the flower, then begin the petals. Work one petal at a time, reducing the size of your brush for smaller areas as directed in the step 1 close up on the next page.

EASY ON THE COLOR

Keep it simple; you can always come back later. There is usually enough pigment in the wash bucket to break up the stark white of the paper. The only other addition of color may be for the shape.

step 1 close-up | petals one by one

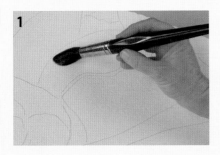

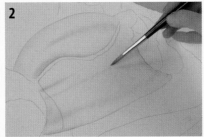

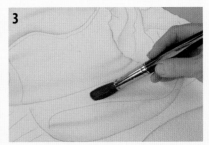

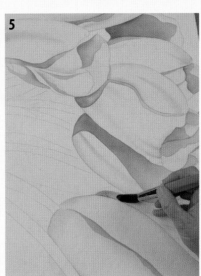

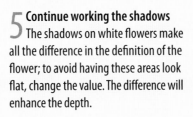

1 Apply water
Use a no. 30 natural-hair round to apply water, covering any pencil shadow lines.

2 Add shape
Mix a couple different color combinations: French Ultramarine and Burnt Umber, and Naples Yellow and Quinacridone Magenta (even palette mud, the blended color left in the palette, works). Using a no. 8 synthetic round, add shape to the damp petal. Don't overdo it, or your flower will no longer be white.

3 Begin the shadows
After all the flowers have shape, reapply water only to the shadow areas using a no. 30 natural-hair round. Then add some of the French Ultramarine and Burnt Umber mix with a no. 20 sable/synthetic blend round.

4 Change values in the shadows
Build darker values as you work the shadows. Keep the darkest shadows inside the flowers or underneath the petals where there is less light. Transition to lighter values toward the tip.

5 Continue working the shadows
The shadows on white flowers make all the difference in the definition of the flower; to avoid having these areas look flat, change the value. The difference will enhance the depth.

2 Add the stems

Use the same technique you used for the petals. Mix Permanent Sap Green and French Ultramarine on your palette. Then, using a no. 8 synthetic round, apply color to the outside edge of the stem, allowing it to run back into the center. To make the stem more interesting, apply a stroke of Quinacridone Magenta along one side.

Once the stems are dry, paint in their shadows using a darker value of the stem mixture and the no. 8 synthetic round.

3 Begin the background

Mix a little Indigo or French Ultramarine into the remaining stem color on your palette. Use a combination of wet-into-wet and color applied directly to dry paper. Use the no. 30 natural-hair round and clean water to help pull the color along.

4 Use the darks

To brighten the whites, use the shadows and dark Indigo background. More layers may be needed to deepen the hue; use the previous layer as your guide as you repeat step 3. For corners or tight areas, use a no. 8 synthetic round, switching to the no. 30 natural-hair round to pull the remaining color out into clean water.

Finished painting

By starting with the subject and adding the background later, you avoid the risk of the background colors bleeding into your white subject.

WHITE TULIPS
40" × 30" (102CM × 76CM)
WATERCOLOR ON 300-LB. (640GSM) COLD PRESS

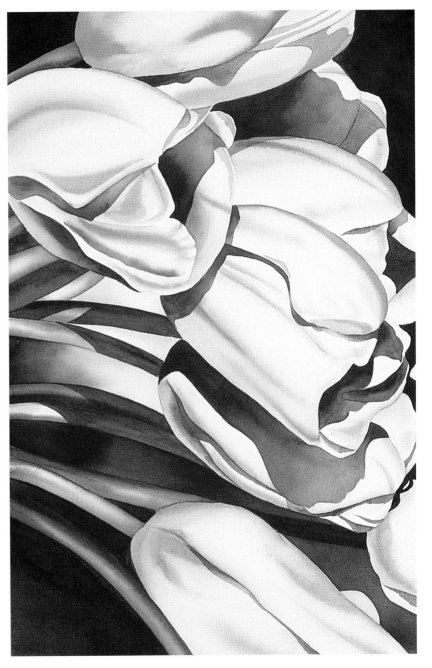

adding details

So far, we've focused on allowing your paint to move and blend itself on your paper to achieve natural-looking blends. But how useful is this technique when you're trying to add fine details to your paintings? Veins in a flower can be some of the most intimidating and overwhelming details to add. They can easily appear overworked and dry, as if they were an afterthought and stuck on top of the flower.

The key is to know how your paper is drying and when to add details with this very fluid medium. Once you learn this, you'll be able to add the detail you want and make that detail look as if it belongs to the painting.

Keep the viewer's focus on the subject
The veins in a flower can give direction to a composition and are important details. But how do you keep the focus on the flowers themselves and not on the veining detail? Using different colors and abstracted shapes in the background keeps the main focus of the painting on the subjects.

WILD DOUGLAS IRIS
40" × 60" (102CM × 153CM)
WATERCOLOR ON 1114-LB. (2340GSM) COLD PRESS

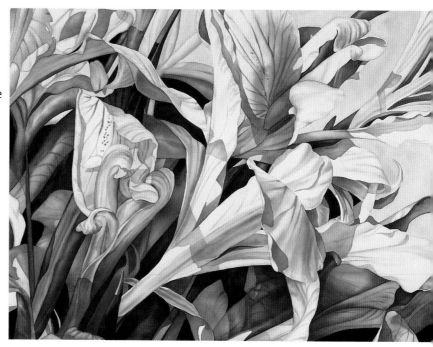

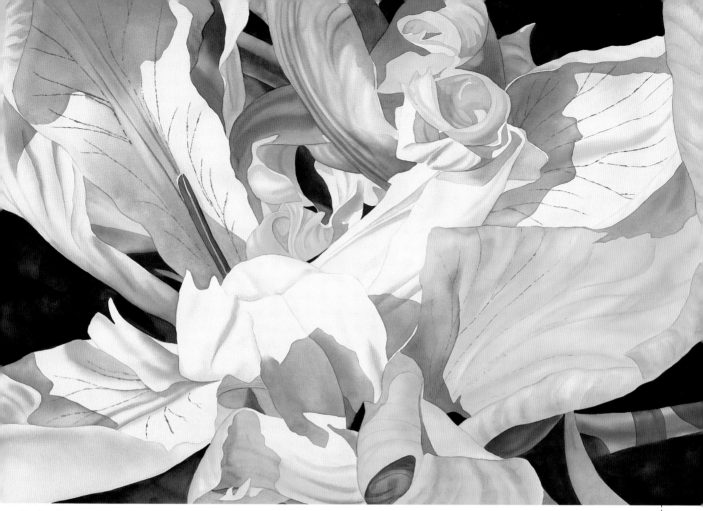

Use details to enhance the composition

The flowers of the wild iris have very thin petals. One flower alone would be a very weak painting. In this case, adding more flowers and using the details of the bloom, such as the dry petal curl and fold, adds interest to the composition. Because this is a more abstracted image, the veining helps give the viewer direction.

MILLENNIUM
40" × 60" (102CM × 153CM)
WATERCOLOR ON 1114-LB. (2340GSM) COLD PRESS

controlling color for soft details

Most of the time it is not necessary to paint every little detail, but in some cases the detail is the most striking part of the flower. Irises are a perfect example. Each flower contains a variety of different petal sizes. Their common thread is the striking contrast of the veins in the center of the flower.

MATERIALS

Paper | ½ sheet 300-lb. (640gsm) cold press

Brushes | Nos. 8, 14 and 20 sable/synthetic blend rounds • Nos. 3 and 20 synthetic rounds • 2½-inch (6cm) bamboo hake, mop or wash brush

Pigments | French Ultramarine • Hansa Yellow Medium • Indian Yellow • Indigo • New Gamboge • Permanent Sap Green • Phthalo Blue • Quinacridone Magenta • Yellow Ochre

Other | Graphite pencil

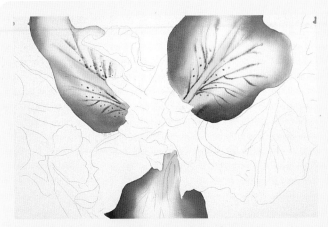

1 Begin with a sketch and paint the large shapes
Lightly sketch the flower and begin the largest shapes (see step 1 close-up); this helps build the foundation and direction. Don't try to make perfect petals. Work the overall painting, then reevaluate. You want only to give the impression of veins, not replicate every one (that would be distracting).

Water to color
The color mixture for fine, detailed veins should be a bit drier, with more pigment than water. If the color is too wet, it will disburse too easily; if it's too dry, the color won't move. Experiment on scrap paper before applying the color to your painting.

step 1 close-up | first layer

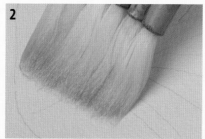

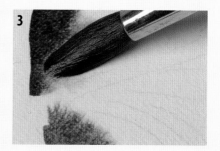

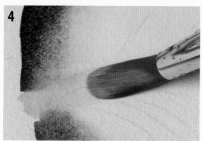

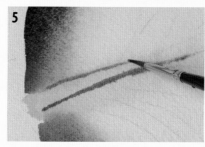

4 Add the complementary color
The space between the purples allows room for the complementary colors to be side by side without turning muddy (see page 78). Using a no. 20 synthetic round, apply a swift stroke of Hansa Yellow Medium or Indian Yellow and New Gamboge mixture from your palette to the center of the inside edge and sweep it across the petal toward the outside.

1 Mix your color
On your palette, mix French Ultramarine or Phthalo Blue and Quinacridone Magenta.

2 Begin with one petal
Using your hake, fill one petal with clean water, almost to the pencil line, leaving a small, dry space between the edge of the water and pencil line. This space defines the edge and leaves a cleaner line.

3 Apply color to the paper
While the glisten is still on the paper, load a no. 20 sable/synthetic blend round with the purple mixture. Randomly apply color along the edge of the pencil line, allowing the color to run back from the edge of the pencil line into the clean water. Leave a small white space between the purples in the center.

5 Apply the vein detail
Once the surface loses its shine and becomes more matte, apply the vein on top of the yellow using a drier color mixture and a no. 3 synthetic round. Begin in the center and sweep it out to the edge in a branching motion. For a tapered line, sweep and lift the brush.

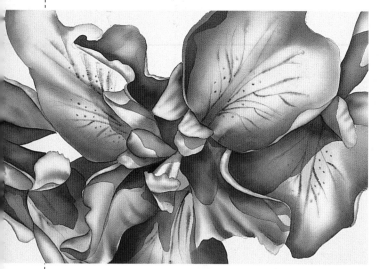

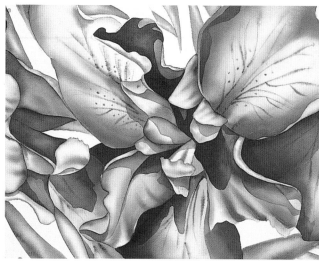

2 Continue the petals, building color

Apply layers of color as needed. Build shape by using different values. If a darker purple is needed, add a touch of Indigo. If your purple is too blue, add more Quinacridone Magenta or neutralize it with some Hansa Yellow Medium or Indian Yellow. You can stop here, leaving the background white for a more decorative and safer painting. Or you might want to be bold and push it a little further and add more dimension.

3 Add a background

For a stronger background, begin adding leaves, grasses and other details (remembering that too many details can be distracting) using your nos. 8 and 14 sable/synthetic blend rounds and Permanent Sap Green, New Gamboge, Indigo, Yellow Ochre and French Ultramarine. Use a combination of detail (the technique you used for the veins on page 80) and the wet-into-wet technique.

4 Finish

If it isn't obvious to you which areas need more color or depth, step away from the painting or rotate it on its side. By looking at it as an abstracted form, you are no longer focusing on only one area but seeing the overall painting and finding balance. To minimize distracting details in the background, apply a wash of Permanent Sap Green, French Ultramarine or New Gamboge. To push the background back further, add more Indigo to your mixture.

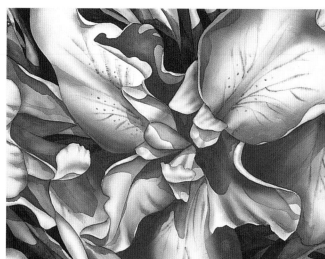

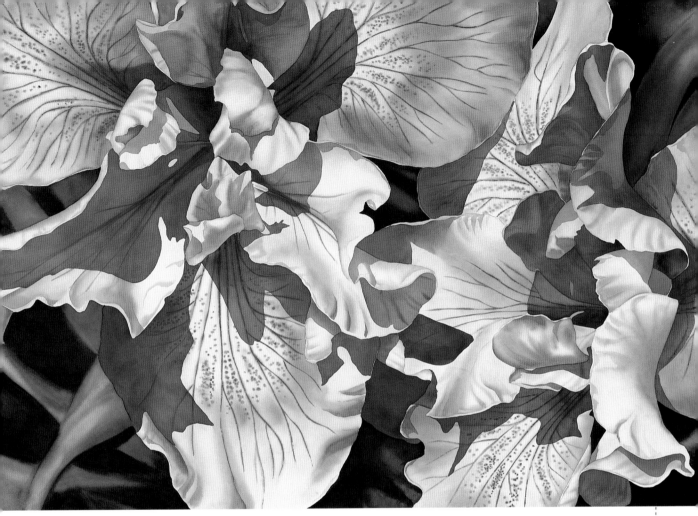

Push your subject forward

Combinations of values, hard and soft edges, complementary colors, shadows and careful placement of the background and veining detail all work to pull this painting together. You can see how the values help to create shape within the petals and how the complementary yellow inside the flowers and the dark greens of the background push the flowers forward.

PACIFIC
40" × 60" (102CM × 152CM)
WATERCOLOR ON 1114-LB. (2340GSM) COLD PRESS

controlling color using masking

Stargazer lilies are basically white flowers with bold strokes of color in the center of each petal. The challenge here is to control color within a designated area and not allow it to flood to the edges of the petal. This is a good example of how using the right brush gives you more control over the medium. In this case, masking will come in very handy, allowing you to continue the flow of color without interruption.

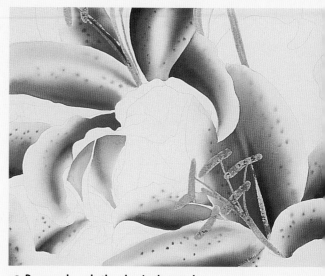

1 Draw and mask, then begin the petals

Lightly sketch the flower, then mask the stamens and let the mask dry completely.

For the petals, prepare a mixture of some or all of the reds. Paint the petals one at a time as directed in the step 1 close-up.

MATERIALS

Paper | ½ sheet 300-lb. (640gsm) rough or cold press

Brushes | No. 30 natural-hair round, mop or hake • No. 14 sable/synthetic blend round • Nos. 3 and 8 synthetic rounds

Pigments | Carbazole Violet • French Ultramarine • Hansa Yellow • Indanthrene Blue • Indigo • Permanent Alizarin Crimson • Permanent Carmine • Permanent Sap Green • Phthalo Green • Quinacridone Magenta • Winsor Red

Other | Graphite pencil • Masking fluid

step 1 close-up | petal

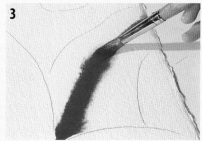

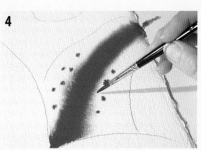

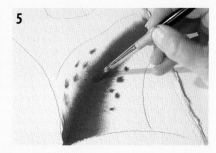

1 Apply water
Using a no. 30 natural-hair round, apply water to the inside of one petal, almost to the pencil line.

2 Begin the stroke of red
As the shine leaves the paper, load a no. 14 sable/synthetic blend round with your red mixture. Apply a sweeping stroke starting at the base of the petal and brushing out toward the tip. As you reach the tip, sweep and lift the brush for a tapered line.

3 Stroke again
To intensify the color and widen the stroke, apply another stroke over the first, again beginning at the base and moving toward the tip. Minimize the number of strokes and don't brush back and forth.

4 Add the details
While the surface is still damp, use a no. 3 synthetic round to apply small dots of color of the same red mixture. Practice on a separate piece of paper first so you know how dry the paper needs to be for optimum results.

5 Darken if needed
If the color is lighter than you would like, you can apply more color, but the paper must still be damp enough, or you will lift out the first application. If this happens, wait until the first layer is completely dry before reapplying.

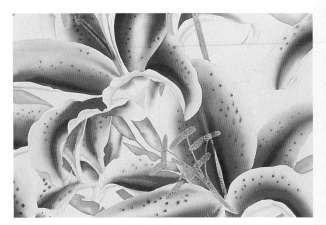

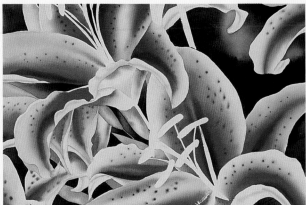

2 Darken the petals, then add the greens

As the color from step 1 dries, it will lighten. If necessary, intensify and deepen your red mixture by adding a little Carbazole Violet to it; then apply a second or even a third layer. Once all the petals are filled with color, begin the stems and leaves using a mixture of Permanent Sap Green, French Ultramarine and Hansa Yellow.

3 Paint the background

Let the painting dry completely. For the background, mix Phthalo Green and Indanthrene Blue; this will give you a crisp, clean color to complement the magentas and reds. If you think the mix needs to be darker, add a little Indigo. Paint the background one continuous section at a time, following the step 3 close-up.

Let everything dry, then remove the mask from the stamens by rubbing with your finger.

4 Paint stamens and details to finish

Paint the stamens much as you did the petals: Fill each one with water, then add color as the shine starts to disappear. Apply a very light value of green along both edges of each filament to give them form. For the anthers (the structures at the tops of the filaments), use a mixture of Hansa Yellow, Permanent Alizarin Crimson and a little Carbazole Violet. When all the petals, stamens and stems are filled with color, reevaluate the overall painting and adjust values as needed.

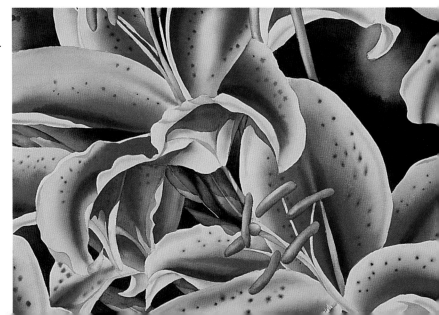

step 3 close-up | background

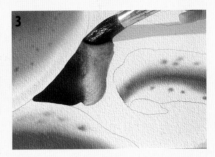

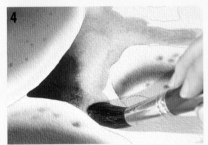

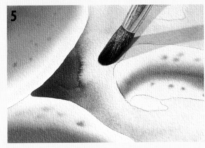

1 Start in the corner …
Begin with dry paper for the darkest possible hue. Cut into the corners using a no. 8 synthetic round. This brush will give you optimum control and a nice, clean edge.

2 … and work outward
Paint out from the corners, using large sweeping strokes to avoid an overworked appearance.

3 Dilute with water as you go out
Using clean water on a no. 30 natural-hair round, start pulling out the darker hue into the background. The resulting variations of value will add interest.

4 Continue pulling out color
Following the forms of the petals, continue to pull the color out and around.

5 Finish the section
Continue pulling color around with clean water on the brush, not stopping until you have filled that particular background section.

using depth and dimension

Adding water drops to a painting creates a three-dimensional illusion and leaves a lasting impression of amazement with the viewer. Before beginning this demonstration, practice along with the water-drop exercise on the DVD.

MATERIALS

Paper | ¼ sheet 300-lb. (640gsm) cold press

Brushes | ¼-inch (6mm) nylon flat · No. 30 natural-hair round · No. 20 sable/synthetic blend round · Nos. 8 and 20 synthetic rounds · 2- to 3-inch (5cm to 8cm) bamboo hake or wash brush

Pigments | Carbazole Violet · Indian Yellow · Indigo · Permanent Alizarin Crimson · Permanent Sap Green · Quinacridone Magenta

Other | Cotton swab or old, stiff synthetic brush · Graphite pencil · Incredible nib or bamboo drawing pen · Masking fluid · Old acrylic brush, cotton swabs or paper towel · Rubber eraser

1 Draw and mask
Decide where your want your water drops and apply the masking fluid. (Don't add too many drops, or it will look like bubbles or something underwater.) The highlight should face the direction of the light source.

2 Apply water
Once the masking fluid is dry, start your painting, paying no attention to where the water drops will be. Work with only one petal and use a wash brush to apply water. You are going to paint as you would any other petal.

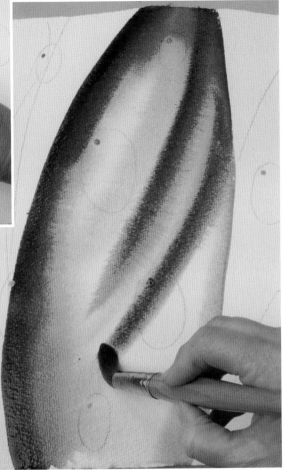

3 Apply color
Using a no. 20 sable/synthetic blend round, mix Permanent Alizarin Crimson and Quinacridone Magenta. Add color along the edge of one side and sweep across the middle of the petal. Add a couple strokes of Indian Yellow next to the red and along the other side to make the bud more interesting.

4 Move the color
While the color is still wet, lift and move the paper so the color blends on the surface. Using different hues in the painting helps add more depth to the water drops.

Repeat steps 2, 3 and 4 to complete the other petals and the background.

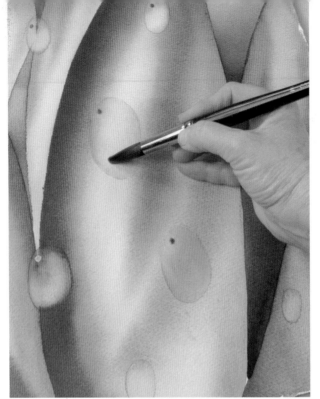

5 Develop the water drops

When the painting has been completed and dried, start to work on the water drops, one at a time. Fill each drop with water; then, using a stiff ¼-inch (6mm) nylon flat or cotton swab, lift out color along the bottom and sides.

6 Add the shadows

On the opposite side of the highlights, add the shadows using a no. 8 synthetic round and the same pigment mixture as you did for the bud, except with the addition of Carbazole Violet or Indigo.

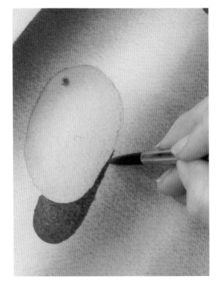

7 Remove the masking

When you're done with the water drops and everything has dried, use your finger or a rubber eraser to reveal the highlight and remove the masking fluid.

Water drops add interest ▶

With the dimension water drops bring, they can take a simple composition and make it much more interesting.

CANNA WITH WATER DROPS
40" × 30" (102CM × 76CM)
WATERCOLOR ON 300-LB. (640GSM) COLD PRESS

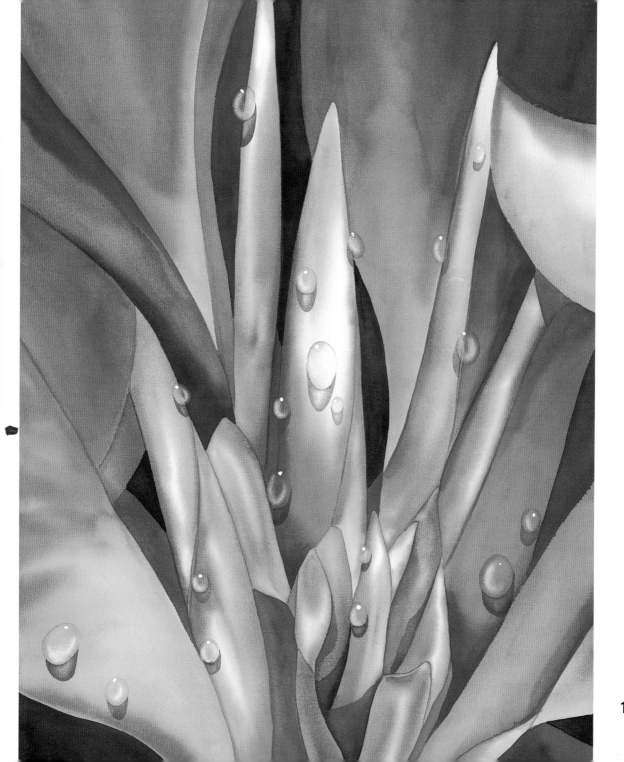

Index

Ideas. Instruction. Inspiration.

Receive FREE downloadable bonus materials when you sign up
for our free newsletter at artistsnetwork.com/Newsletter_Thanks.

These and other fine North
Light products are available
at your favorite art & craft
retailer, bookstore or online
supplier. Visit our websites
at artistsnetwork.com and
artistsnetwork.tv.

 Follow North Light Books for the latest news, free wallpapers,
free demos and chances to win FREE BOOKS!

Visit artistsnetwork.com and get Jen's North Light Picks!

Get free step-by-step
demonstrations along
with reviews of the lat-
est books, videos and
downloads from Jennifer
Lepore, Senior Editor and Online Education Manager
at North Light Books.

Get involved

Learn from the experts. Join
the conversation on